Italian maiolica

Timothy Wilson

**Sponsored by
Christie's Fine Art Auctioneers
London**

Phaidon · Christie's Limited
in association
with the Ashmolean Museum

First published 1989
Phaidon · Christie's Limited
Musterlin House, Jordan Hill Road, Oxford OX2 8DP

Published in association with the Ashmolean Museum
Text and illustrations © Ashmolean Museum, Oxford 1989
Published in paperback by the Ashmolean Museum, 1989

ISBN 0 7148 8069 8 (hardback)
ISBN 0 907849 90 3 (paperback)

A CIP record for this book is available from the British
Library

Cover illustration: Plate, a winged putto on a hobby
horse, Plate 9

Designed by Cole design unit, Reading
Set in Versailles by Meridian Phototypesetting Limited
Printed in Great Britain by White Brothers (Printers) Ltd,
London

Preface

This selection from the maiolica and related ceramics at the Ashmolean Museum is designed as an introduction to this vividest of Renaissance 'minor arts'. Fewer than a third of the pieces in the Fortnum collection are included, and only two of the eighteen pieces added since Fortnum's death in 1899. Scholarly apparatus, bibliography, and discussion have been kept to the minimum. It is thus not a catalogue, and is not meant to pre-empt the full modern scholarly treatment which this collection deserves – and which many far lesser ones have already received.

I am grateful to Nicholas Penny, Keeper of Western Art, for encouragement to write this booklet, and to his colleagues at the Ashmolean for help of various kinds, especially Noelle Brown, Christopher Lloyd, Ian Lowe, and Jon Whiteley; and to Neil Stratford, Keeper of Medieval and Later Antiquities at the British Museum, for permission to undertake the work. I have a particularly warm sense of gratitude, for his unfailing advice and encouragement, to John Mallet, until recently Keeper of Ceramics at the Victoria and Albert Museum, and the most recent of a great line of scholar-keepers of his department. I also thank Sandro Alinari for his comments on the Tuscan pieces and Carola Fiocco for advice on Umbrian pieces. The photographs are, except where otherwise credited, the work of Michael Dudley of the Ashmolean Museum. I am most grateful to Mr Dudley for the patience and sensitivity he has given to this task.

Introduction

This book is designed to present an overview of the artistic achievement of the ceramics of Renaissance Italy. That this can be attempted with only 34 items selected from a small museum collection is testimony to the discrimination of a remarkable Victorian who is deservedly considered the 'second founder' of the Ashmolean Museum.

Charles Drury Edward Fortnum (known as Drury Fortnum), was born in 1820 to a branch of the family made wealthy by the famous Piccadilly grocery business, Fortnum and Mason. Collecting and classifying seem to have been in his blood. In his twenties, he lived in Australia and formed a substantial collection of natural history specimens. On his return to England in 1845, mainly through two successive prudent marriages to heiress cousins, he became rich enough to spend the rest of his life as a gentleman connoisseur and to form over the next forty years collections of sculpture, ceramics, bronzes, glass, and finger rings, ranging in date from pre-Classical times to his own century. He was closely associated, from its foundation after the Great Exhibition in 1851, with the South Kensington Museum (now the Victoria and Albert Museum), and for many years acted as an agent for the museum on his travels abroad – unpaid, since accepting a commission would have made him appear a dealer, not a gentleman. In 1873 he provided the South Kensington with the first catalogue of its maiolica collection, a monumental volume whose massing of marked specimens make it still a cornerstone of modern attributional scholarship. His 1876 catalogue of European bronzes in the same museum has been almost equally influential. He died in 1899[1].

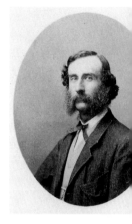

Drury Fortnum, a photograph taken from an album now in the Ashmolean showing his collection displayed in his home, The Hill House, Stanmore.

[1] For Fortnum, see *The Dictionary of National Biography*; J.V.G. Mallet, 'C.D.E. Fortnum and Italian Maiolica of the Renaissance', *Apollo* 108 (1978), pp. 396–404, and 'Storico e storicismo: Fortnum, Cantagalli e Castellani', *Faenza* 64 (1978), pp. 37–47; Christopher Lloyd, 'Two large Plaquettes in Oxford from the Collection of C.D.E. Fortnum' [NGA Washington, imminent.]

Despite his connections with the South Kensington Museum, and his admiration for the great Renaissance scholar J.C. Robinson, who more than anyone else created that museum's Renaissance collections, there is no evidence that Fortnum ever seriously considered his collection being merged into the vast collections at South Kensington. But in any case he lost confidence in the Museum's administration, describing it in 1892 as a 'rich but somewhat too heterogeneous collection, for latterly by purchase and by gift, in some instances of objects scantily worthy, and perhaps by a somewhat less effective management and direction and ever-increasing want of space, it has become such a crowded "omnium gatherum" of ill-arranged and ill-assorted specimens that one loses oneself as in a maze'[2]. Not surprisingly, he preferred a smaller institution where his collections would be pre-eminent, and from the late 1860s he seems to have begun considering the Ashmolean as a final home for his beloved objects. To give these superb things to Oxford was not as simple a task as it might seem: there was nowhere they could easily be housed and there was a faction in the University, led by the Classical scholar and highly influential University politician, Benjamin Jowett, which argued that the Ashmolean ought to restrict its scope to Classical archaeology[3]. But Fortnum's offer was too good to turn down, and in the 1880s he made over large parts of his collection, following them up with a generous sum of money to transform the old University Galleries into what is now the Ashmolean Museum building. In Italian maiolica, as in the other fields he collected in, Fortnum's collection remains the basis of the Ashmolean's holdings, and the modest subsequent additions have not changed its character.

Fortnum's letter offering the collection expressed the hope that it 'will be made useful by promoting the study of the history and archaeology of various branches of the applied arts, and thereby afford pleasure and mental culture to others'[4]. This rather academic perspective reflects the nature of the

[2] *Archaeological Journal* 49 (1892), p. 288. He was perhaps influenced by Robinson, who had been meant to write the maiolica catalogue but had quarrelled badly with the South Kensington management in the 1860s and wrote to Fortnum in 1869: 'My opinion is that catalogues of any kind would be entirely useless and superfluous in the state of disgraceful confusion which reigns at present in that institution' (Ashmolean Museum Library, Fortnum Correspondence, 5 March 1869). For the quarrel, see A. Burton, 'The image of the curator', *V & A Album* 4 (1985), pp. 373–378.
[3] Joan Evans, *Time and Chance* (London 1943), pp. 261–307.
[4] *Oxford University Gazette*, 27 Nov. 1888, cited by Lloyd (see note 1).

maiolica collection – the study collection of a tireless scholar and connoisseur of the subject. In the preface to his catalogue of his own maiolica, published in 1897, he wrote: 'Not aspiring to the acquisition of the larger and more grandiose pieces, which even then demanded a prohibitive outlay, his main object was to obtain fairly representative examples of the various Italian fabriques, and of the master potters who worked at them, as also signed and dated or marked pieces when such could be secured'[5]. Fortnum was a modestly wealthy man, who had the opportunity to travel widely, especially in Italy, but he could rarely compete in the booming market for maiolica in the 1850s, 1860s, and 1870s with Rothschilds and others of comparable buying power, for the most lavish and elaborate examples. Furthermore, he sometimes felt himself under an obligation to offer his best 'finds' to the South Kensington Museum. Despite this, Fortnum's expertise, eye for quality, and determined search for pieces of documentary importance were such that his modest collection of a hundred and twenty or so pieces is one of the world's crucial collections for the study of Renaissance maiolica.

Although Fortnum sought to illustrate the development of artistic pottery over a long period, the outstanding area of his ceramic collection is the Italian maiolica of the first half of the sixteenth century, and he shared the general view of his generation in concentrating on *istoriato* works of the High Renaissance. His view was that 'the choicest works in Italian pottery were produced during a period which extended from 1480–90 to 1520 or 1530; thence till 1550 was its meridian, although some fine works were produced at Urbino by the Fontana till 1570; before which time we find that the ruby lustre had been lost, and rapid decadence of design and execution reduces all to painful inferiority'[6]. The collection is (despite a few subsequent acquisitions by the Museum) relatively weak in the medieval and early Renaissance wares which have been of consuming interest to some twentieth-century

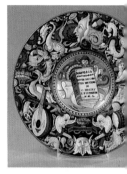

A maiolica plate made for Fortnum by Cantagalli of Florence in 1889 and painted by Ulderigo Grillanti, showing the South Kensington catalogue. Cantagalli was the most distinguished firm producing neo-Renaissance maiolica in late nineteenth-century Italy: it is a measure of Fortnum's reputation that the plate is inscribed as presented by the artists of the factory to 'their guide in the art'.

[5] Fortnum 1897, p. vi.
[6] Fortnum 1896, p. 38, cited by Mallet 1978.

collectors. Like all such nineteenth-century collections, formed long before the beginning of systematic archaeological investigation of Renaissance sites, it is a collection of 'art pottery', and in no way representative of the day-to-day pottery used on ordinary Renaissance tables, which virtually never survives above ground.

The focus of Fortnum's interest was a characteristically Victorian fascination with the 'industrial arts', and a characteristically 'South Kensington' interest in the history of pottery as a subject in its own right. The one real defect in the South Kensington *Catalogue* is the lack of a detailed consideration of the relation of maiolica to painting, engraving, and the other arts of sixteenth-century Italy. A century on from Fortnum's gift, we are more inclined to look at maiolica as a characteristic and significant aspect of the wider artistic and cultural achievement of the Italian Renaissance. Both perspectives are essential. Yet neither at Oxford, nor elsewhere, have Fortnum's hopes that his collection would promote 'the study of the history and archaeology of various branches of the applied arts' yet been fully realised; nor is maiolica often studied alongside other forms of Renaissance painting. Fortnum's wonderful objects are a standing reproach to the fact that the 'industrial arts' have still not established their proper place in the mainstream of university art history in Britain.

Making maiolica

Maiolica is earthenware covered with an opaque white (or tinted) tin glaze. 'Delftware' and 'faience', made in other parts of Europe in the seventeenth and eighteenth centuries, are technically the same kind of pottery.

The techniques of Italian Renaissance maiolica are known to us mainly through an incomparable source, the *Three Books of the Potter's Art*, a manuscript treatise written about 1557 by Cipriano Piccolpasso of Castel Durante and now in the Victoria and Albert Museum. Piccolpasso's explanations of how maiolica was made in Castel Durante in the middle of the sixteenth century are supplemented by his careful and evocative drawings. The reader is referred to the superb facsimile edition and commentary by Ronald Lightbown and Alan Caiger-Smith (London 1980) for detailed assessment of Piccolpasso's evidence.

The manufacturing processes of Renaissance maiolica described by Piccolpasso are, briefly, as follows. Clay was dug, mainly from river beds, and purified. The dish or vessel was thrown on the wheel or pressed into plaster moulds, then given a first firing to about 1000°C in a wood-fired kiln. The ware was then dipped in a glaze of which the main constituents were potash (made from burning the lees out of wine barrels), sand, and oxides of lead and tin. When the glaze was dry, the powdery surface was painted. The principal colours were blue (from cobalt), green (copper), purple and brown (manganese), yellow (antimony), orange (antimony and iron), and white (tin). The painted vessel was sometimes given a top coating of transparent glaze and was then fired again to completion at a

somewhat lower temperature. Dishes were usually supported in the kiln on small pointed spurs, and most have three or more scars on the front where these spurs touched the surface.

Numbers 5, 7, 8, and 11 in this selection are further enriched with metallic lustre, a process learnt from Spain or the Islamic world shortly before 1500. Compounds containing oxides of silver or copper were painted onto the twice-fired pottery, which was then refired at a lower temperature. Towards the end of this firing the vents were blocked and the kiln was allowed to fill up with smoke; carbon monoxide combined with the metal oxides, causing a thin layer of pure metal to be deposited in the surface; when cleaned, this produced a much-admired iridescent effect.

Maiolica of the type which was treasured enough over the centuries to survive for nineteenth-century collectors like Fortnum to acquire, was 'art pottery', constituting only a tiny proportion of the production of Renaissance potteries. To us, *istoriato* pottery is above all a painter's art, a branch of Renaissance painting as well as a chapter in the history of ceramics; when a piece is said to be 'by' Nicola da Urbino or another, it is the painting which is meant, rather than the throwing of the pot, which may have been done by another artisan. This necessary art-historical perspective, however, should not disguise the fact that pottery painters in the sixteenth century were not the aristocrats of the craft; although sometimes aspiring to the new status of 'artist', they were often mere journeymen, employed by workshop owners substantially higher up the social and economic scale.

1 Spouted bowl
Orvieto, (late) thirteenth/fourteenth century

This bowl is a fine example of what is sometimes called 'archaic maiolica'. The technique of covering earthenware with a glaze made opaque by the addition of tin oxide, and painting on this glaze, was introduced into Italy from the Islamic world around 1200. Throughout central and northern Italy until well on into the fourteenth century, the palette was limited to copper green and a purple or brown derived from manganese. The significance of the subject – apparently two queens flanking a pillar – is obscure.

In the ten years before the First World War, vast quantities of medieval maiolica were excavated in the town of Orvieto. Although the history of the Ashmolean bowl is unknown, it is shown in an album of photographs, made around 1909, of pottery apparently dug up in Orvieto; there is therefore every reason to believe it to be from the same source[1]. In design, it is fairly typical of Orvieto finds, and it was probably made locally. In the absence of systematic archaeological investigation of Orvieto or related sites, accurate dating of pieces like this is impossible.

This type of pottery, which is hardly ever preserved above ground or intact, had been of little interest to Fortnum and the collectors of his generation: nothing of the sort is included in the Fortnum Bequest. In England there are large collections of medieval maiolica, mainly from Orvieto, at the British Museum and the Fitzwilliam Museum, Cambridge.

Maiolica, tin-glazed inside and out.
Width including handles: 29 cm.
Condition: Restored from fragments, with some patches of infill.
Provenance: Purchased 1954 from K.D. Gloag and Miss Gloag.
Bibliography:
Report of the Visitors of the Ashmolean Museum 1954, p. 61.

[1] For Orvieto medieval pottery and the 'Orvieto boom', see *Ceramiche medievali dell'Umbria*, exhib. cat., Spoleto, 1981; *La ceramica orvietana del medioevo*, exhib, cats.: part 1, Milan 1983; part 2, Orvieto 1985. The photographic album is in the British Museum, the gift of Dr David Whitehouse.

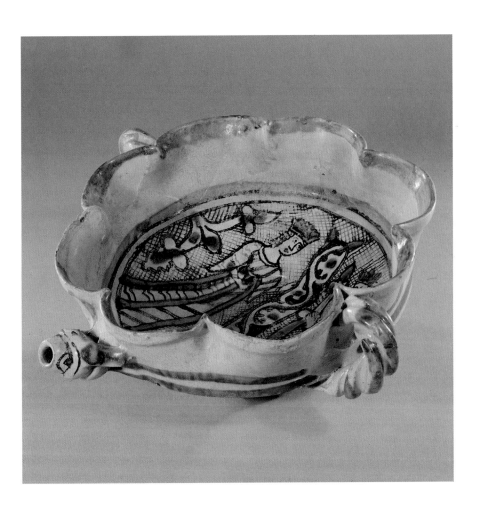

2 Jug
Florence region, *c.* 1460–90

The arms are those of the degli Alessandri, one of the principal families in Renaissance Florence[1].

The jug is an imposing example of the 'Italo-Moresque' style developed by Tuscan potters in the third quarter of the fifteenth century. The so-called 'bryony-flower' decoration on the sides is derived from the lustred pottery of Valencia, on the east coast of Spain. Quantities of Valencian ('Hispano-Moresque') lustreware were imported into Italy throughout the fifteenth century, and a high proportion of it was decorated with this pattern in blue and lustre: it was much imitated in Tuscany, though the Italian potters were unable to produce lustre, and had to use orange instead[2].

In the Islamic world, pottery had long been a luxury commodity: Valencian lustreware, the direct inheritor of this Islamic tradition, was a standing inspiration to Tuscan potters and a major factor in the rise of pottery in Italy during the Renaissance from the merely utilitarian to the status of an art.

Maiolica, tin-glazed inside and out. Marked beneath the handle with an S between four dots, painted in manganese purple.
Height: 35 cm.
Restorations to lip.
Provenance: Fortnum Bequest, 1899.
Bibliography:
Fortnum 1873, p. 101, no. 14;
Fortnum 1896, p. 131, pl. IX, 'Marks and Monograms', p. 8, no. 24;
Fortnum 1897, p. 58, no. C404;
G. Cora, *Storia della maiolica di Firenze e del contado: Secoli XIV e XV* (Florence 1973), tav. 168a; tav. 347, mark M163.

[1] D. Tiribilli-Giuliani, *Sommario storico delle famiglie celebri toscane* (Florence 1855–1864), I, s.v. Alessandri.
[2] Examples of Valencian lustreware for Florentine patrons are illustrated by Wilson 1987, pp. 28–32. Cf. R. Francovich and S. Gelichi, *La ceramica spagnola in Toscana nel Bassomedioevo*, Quaderni dell'insegnamento di archeologia medievale della Facoltà di Lettere e Filosofia dell'Università di Siena 3, Florence 1984, pp. 15–27; M. Spallanzani, 'Maioliche di Valenza e di Montelupo in una casa Pisana del 1480', *Faenza* 72 (1986), p. 166.

A Valencian lustreware jug, *c.* 1450, with the arms of the Medici of Florence; the shape is after an Italian model. This kind of object was the inspiration for 'Italo-Moresque' pottery in Tuscany. By courtesy of the Kunstgewerbemuseum (SMPK), West Berlin.

The potter's mark beneath the handle of the jug. Marking pottery like this was an innovation of fifteenth-century Italy; Valencian pottery never bears such marks.

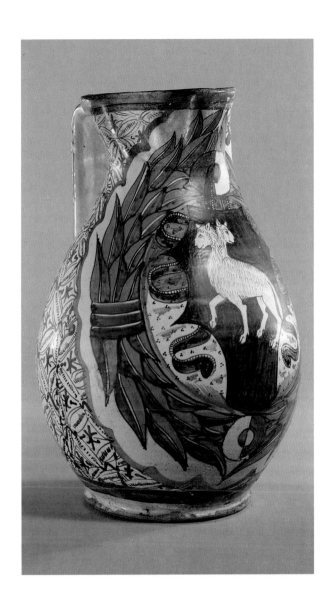

3 Storage jars
Probably Siena, *c*. 1500–1510

These small jars are examples of the type called an *albarello*; the shape was of Islamic origin and became popular in Italy in the fifteenth century. Inscriptions on Renaissance examples show that they were particularly used in spice stores and hospital pharmacies, but examples with the name of the drug or herb written on them are infrequent before 1500. The flanged rim allowed a parchment or similar cover to be put on and tied down.

Fortnum's attribution of these elegant pieces to Siena is likely to be correct[1]. Siena maiolica of the early sixteenth century was strongly influenced by Faenza, the most dynamic maiolica centre of the period: among several Faentine potters who went to work in Siena, the most famous is Benedetto di Giorgio, known as 'Maestro Benedetto'[2].

Maiolica, tin-glazed inside and out.
Height: 13.4 and 13.6 cm.
Provenance: Given by C.D.E. Fortnum, 1888.
Bibliography:
Fortnum 1897, p. 62, nos C411, 412.

[1] An attribution to Siena for similar pieces is given by Rackham 1940, no. 303; Giacomotti 1974, no. 405.
[2] For Maestro Benedetto's role in Siena maiolica, see Wilson 1987, pp. 86–91, with further references.

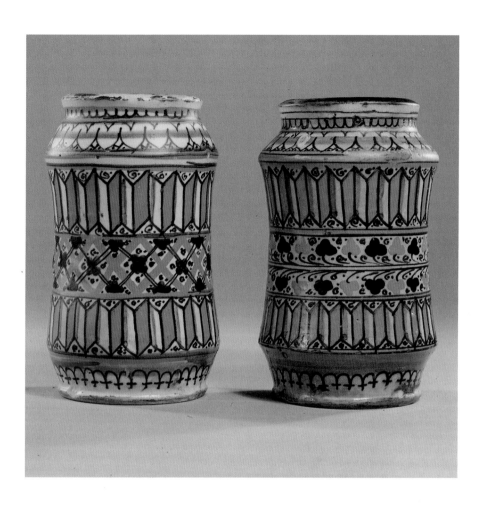

4 Plate, a woman (?) dancing with a bear

Perhaps Faenza (or possibly Siena), *c.* 1500–1510

The decoration is unusual, but the general style and the rings on the reverse link the piece to Faenza work of about 1500. The subject seems fanciful, but may possibly echo some kind of Renaissance street entertainment. No convincing suggestion has been made about the purpose of the implements on the border at two and eight o'clock: they may be a kind of child's windmill.

A plate with the same scene in the centre and virtually identical decoration is in the Victoria and Albert Museum, and another was in the Beit collection[1]. It is highly unusual for a design to recur as precisely repeated as this on three genuine Renaissance objects, and there are grounds for suspicion about the authenticity of both the other examples. The Fortnum Collection plate (which has the longest recorded history of the three) is convincing as a Renaissance object and was perhaps the model for the other two. However, Dr John Leopold of the British Museum points out that the form of the hour-glass is difficult to parallel in the sixteenth century.

Maiolica. Decorated on the back with concentric blue and orange lines.
Diameter: 26 cm.
Provenance: Fortnum Bequest, 1899. Bought by Fortnum in Florence.
Bibliography:
Robinson 1863, no. 5158;
Burlington Fine Arts Club 1887, no. 163;
Fortnum 1896, p. 272;
Fortnum 1897, p. 89, no. C491;
Rackham 1940, p. 73;
B. Rackham, 'Italian Maiolica: Some Debated Attributions; a Follower of Signorelli', *Burlington Magazine* 93 (1951), pp. 108–109, fig. 6.
C. Fiocco and G. Gherardi, *Ceramiche umbre* (Catalogo del Museo Internazionale delle Ceramiche in Faenza, vol. 5, pt I, Faenza 1988), p. 66, suggesting an attribution to Siena and linking the design to the marble pavement in Siena Cathedral.

[1] Rackham 1940, no. 233; A. Van de Put and B. Rackham, *Catalogue of the Collection of Pottery and Porcelain in the Possession of Mr Otto Beit* (London 1916), no. 761 (subsequently sold at Sotheby's, London, 16 October 1942, lot 19, but not illustrated in either place). I am grateful to John Mallet, who has seen it, for his opinion that the Beit plate is unlikely to be of Renaissance date.

16

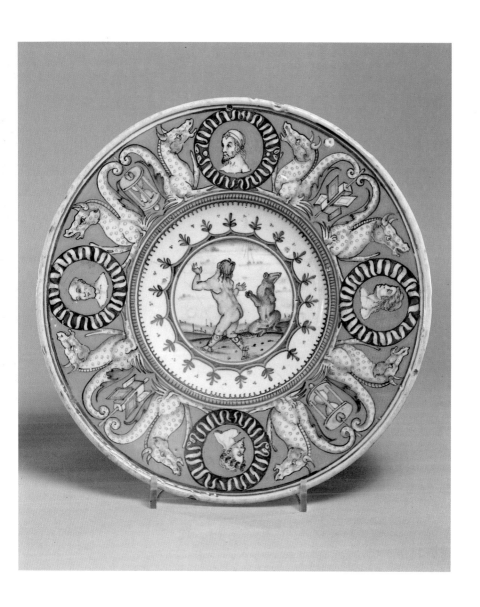

5 Dish, a huntsman blowing his horn
Deruta, *c*. 1500–1530

The small town of Deruta, south of Perugia, has been, since the Middle Ages, dominated by the maiolica industry. In the Renaissance it became one of the principal centres of maiolica production and exported its products all over Italy.

It is not certain where in Italy potters first mastered, shortly before 1500, the technique of applying to tin-glazed pottery in a third firing the iridescent metallic lustre which was so admired on imports from Valencia; but Deruta was among the first and became the most productive of Italian lustreware centres. Its most ambitious products were large lustred dishes of this sort, which usually have holes in the foot ring enabling them to be hung up on a wall. The unsophisticated perspective and lack of modelling, together with the scale-pattern border and stylized plants, are recurrent characteristics of Deruta wares.

No iconographic source for the hunting scene on this dish is known, but the design may reflect a lost fifteenth-century Florentine engraving[1].

Maiolica, with golden lustre; on the reverse a greenish-cream glaze.
Two holes for suspension have been made in the foot-ring.
Diam: 42.4 cm.
Provenance: Given by C.D.E. Fortnum, 1899. Bought by Fortnum in 1854 from the Paris dealer Signol.
Bibliography:
Burlington Fine Arts Club 1887, no. 187;
Fortnum 1897, p.66, no. C423;
B. Rackham, 'Deruta maiolica: some new observations', *Faenza* 46 (1960), pp. 134–137; and 'Deruta maiolica: a further note', *Faenza* 47 (1961), p. 83;
Rackham 1963, pl. 39;
Mallet 1978, p. 400.

[1] Rackham, *op. cit.* 1960.

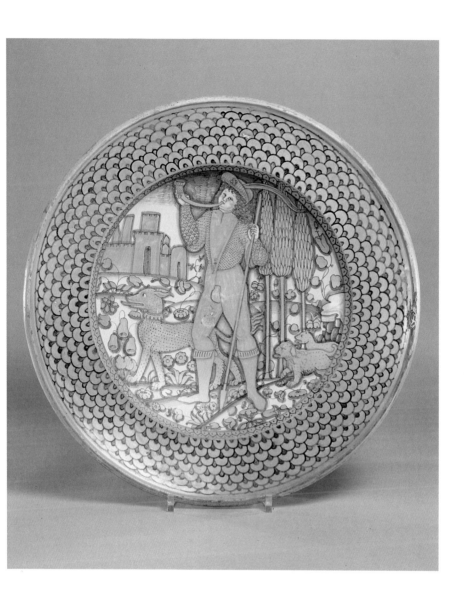

6 Dish, with the head of a warrior
Deruta, *c.* 1500–1525

The concentric bands of ornament and the rather flat drawing, together with the 'petal-back' design on the reverse, make this a typical example of the better quality of unlustred pieces made in the first quarter of the sixteenth century at Deruta. The lustred and unlustred wares of Deruta are often markedly similar in style, and were presumably produced in the same workshops. Deruta was a small town whose potters were conservative in design, so that it is difficult to date its pottery closely. The helmeted warrior is intended to be in the ancient Roman manner.

The dish has a raised ring round the centre, designed to hold an accompanying ewer. Unsurprisingly, such dishes have come down to us in much greater quantity than the more vulnerable ewers. Round the centre, the decoration is executed in white on the slightly off-white glaze, a technique called *bianco sopra bianco*. The 'petal-back' decoration on the back is characteristic of unlustred pieces from Deruta in the first quarter of the sixteenth century; oddly enough, it hardly ever seems to occur on lustreware.

Maiolica, 'petal-back' decoration in blue and orange on the reverse.
Diam: 32.7 cm.
Some retouching; the glaze has flaked on the reverse.
Provenance: Given by C.D.E. Fortnum, 1888.
Bibliography:
Burlington Fine Arts Club 1887, no. 185;
Fortnum 1896, pl. VIII;
Fortnum 1897, p. 59, no. C407.

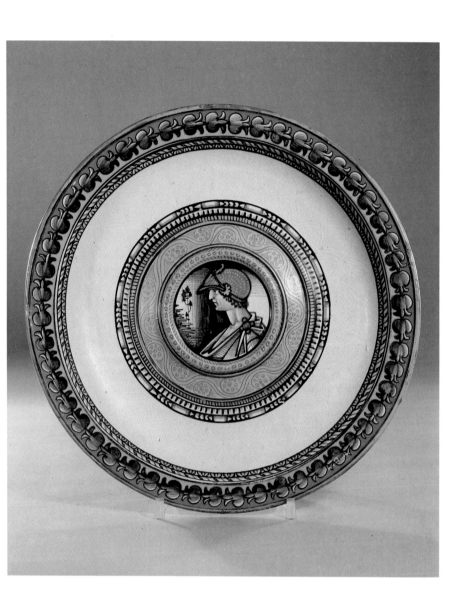

7 Small bowl, a saint reading
Workshop of Maestro Giorgio Andreoli, Gubbio.
Dated 1520

The centre of this bowl is painted with a saint reading; around the edge are dolphin-headed scolls, flowers, a basket of fruit, a winged cherub-head, and panels with the date *1520* and the inscription *ama idio com tutto el core* (Love God with all your heart).

Giorgio Andreoli, usually called 'Maestro Giorgio', was born in Lombardy around 1465–1470. By 1492 he and his brother Salimbene were in business as potters in Gubbio. Giorgio made a speciality of applying lustre to maiolica and he rapidly became one of the most successful of all Renaissance potters. His business was continued by his sons, and Giorgio himself was still alive in 1552. Between 1518 and 1541 Giorgio's workshop regularly marked and dated its lustrewares, and since the mid-nineteenth century these pieces have been among the most avidly collected examples of maiolica[1].

Despite recent archival discoveries, the origins of lustreware in Italy are still unclear. The earliest example bearing a date is a panel in the Victoria and Albert Museum dated 1501[2]. Surviving documents show that Giorgio was producing lustrewares in the 1490s, but no extant piece can be certainly attributed to him before 1515. The pale blue drawing and deep red lustre of this delicately-painted little bowl are characteristic of works made in his workshop around 1520. A similar piece with the same date now in the Wernher Collection at Luton Hoo, Bedfordshire, was perhaps part of the same set[3].

Diam: 18.7 cm.
Maiolica, with red and golden lustre; concentric lustre rings on the reverse.
Condition: Chipped on the foot and rim.
Provenance: Fortnum Bequest 1899. Given to Fortnum by Mr and Mrs Robert Hollond (he was Fortnum's nephew).
Bibliography:
Robinson 1863, no. 5221;
Burlington Fine Arts Club 1887, no. 161;
Fortnum 1896, pl. XIII;
Fortnum 1897, p. 69, no. 430;
Ballardini 1933–1938, no. 102, fig. 99;
Mallet 1978, p. 400, fig. 1;
Wilson 1987, no. 162.

[1] T. Biganti, 'Documenti: La produzione di ceramica a lustro a Gubbio e a Deruta tra la fine del secolo XV e l'inizio del secolo XVI. Primi risultati di una ricerca documentaria', *Faenza* 73 (1987), pp. 209–225.
[2] Rackham 1940, no. 437.
[3] Ballardini 1933–1938, I, no. 101, fig. 98.

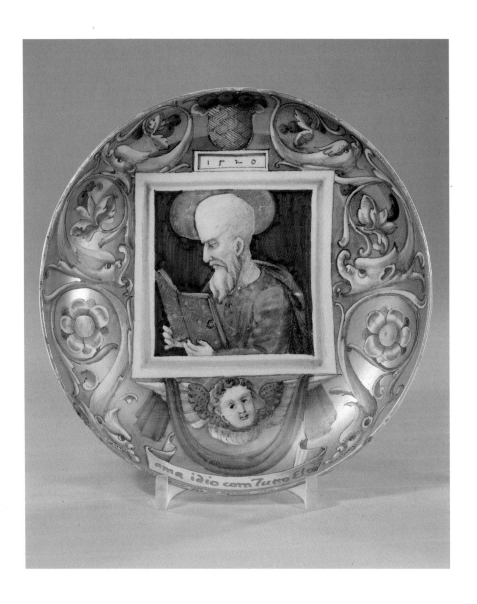

8 Shallow bowl on low foot, Hercules and the Hydra

Probably made in the workshop of Maestro Giorgio, Gubbio, *c.* 1520

Among the legendary 'Labours' of the ancient hero Hercules was the task of killing the many-headed monster the Hydra of Lerna (in Greece), which grew two new heads whenever one was cut off. Hercules vanquished it by burning the ends before new heads could grow.

The figures are based on an engraving made around 1460–70, which is after a design by the Florentine painter Antonio Pollaiuolo and may be based on one of a famous series of lost paintings done by Pollaiuolo for the Palazzo Medici in Florence[1].

This forcefully-painted dish, though difficult to parallel closely in marked works, is probably an early example of *istoriato* production in Maestro Giorgio's workshop. A similar piece by the same painter in the British Museum[2] has the parallel subject of Hercules and the Nemean lion, and perhaps also echoes a design by Pollaiuolo.

Maiolica, with red and golden lustre.
Diam: 32.2 cm.
Restorations to the foot and rim.
Provenance: Fortnum Bequest, 1899. Bought by Fortnum from Bruschetti, Milan, in 1862.
Bibliography:
Robinson 1863, no. 5219;
Burlington Fine Arts Club 1887, no. 160;
Fortnum 1896, pl. XII;
Fortnum 1897, p. 68, no. C429;
R. Langton Douglas, 'The Exhibition of Old Masters at the Burlington Fine Arts Club', *Connoisseur* 5 (1903), p. 274.

[1] A.M. Hind, *Early Italian Engraving* (London 1938–1948), I, p. 194, no. D.I.3; III, pl. 266.
[2] BM, MLA, 1851, 12–1, 6. The two dishes have some affinities with the work of the 'Painter of the Three Graces' (Rackham 1940, p. 223). A note in the Museum copy of Fortnum's manuscript catalogue records that Henry Wallis, the painter and writer on maiolica, considered the Fortnum piece a nineteenth-century imitation, but this seems highly unlikely: the revival of lustreware in Italy took place in the 1850s and the British Museum dish was already in the Museum in 1851.

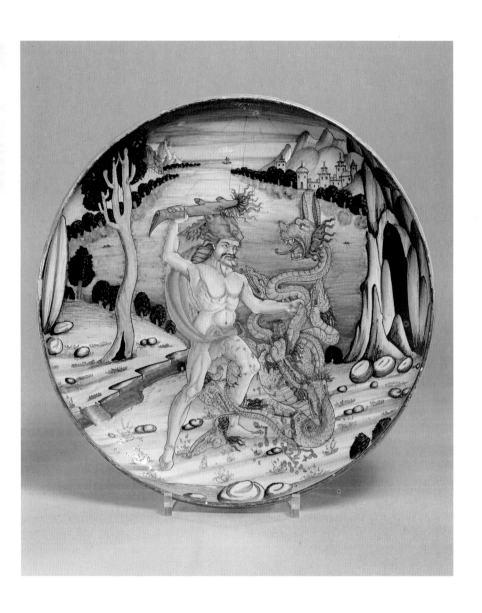

9 Plate, a winged putto on a hobby horse
Probably made in the Urbino region, c. 1510–1520

This delicious plate is painted in the centre with a winged putto playing on a hobby horse in a simple landscape. The border is fantastically painted in a triangular rhythm with fruit and flowers, winged cherub heads, and dolphin-monsters.

Three other plates (in the National Gallery of Art, Washington, the J. Paul Getty Museum in Malibu, and the Victoria and Albert Museum) are each painted with a putto playing within inventively-conceived borders, and may have formed part of a single set[1]. A number of other pieces are more or less closely related, including a bowl now in the Metropolitan Museum of Art which is signed by 'Giovanni Maria' in Castel Durante and dated 1508. It is possible that the playing putto series is also from the workshop of Giovanni Maria, but there is little firm evidence to distinguish the maiolica made in the first twenty years of the sixteenth century in Urbino, Castel Durante, and other places nearby; rather similar pieces may have been made in several centres.

Giovanni Maria himself was probably active in Venice and Urbino, as well as in Castel Durante[2].

Maiolica; on the reverse is a garland in blue.
Diam: 22.8 cm.
Restorations to the edge at 2 o'clock and 5 o'clock.
Provenance: Fortnum Bequest, 1899. Given to Fortnum in 1887 by Augustus Wollaston Franks of the British Museum.
Bibliography:
Robinson 1863, no. 5179;
Burlington Fine Arts Club 1887, no. 166;
Fortnum 1896, pl. XIX;
Fortnum 1897, p. 84, no. C515;
B. Rackham, 'Die Majolikamaler Giovanni Maria von Castel Durante', *Pantheon* 2 (1928), pp. 89–90;
Mallet 1978, p. 401, col. pl. III.

[1] The Washington piece and the work of 'Giovanni Maria' are discussed in T.H. Wilson, 'Renaissance Ceramics', in a forthcoming volume of the *Systematic Catalogue* of the National Gallery of Art. The Getty piece was ex-Strauss sale, Christie's, London, 21 June 1976, lot 22; the V & A one is Rackham 1940, no. 532.
[2] For attributions to this group, see B. Rackham, 'Die Majolikamaler Giovanni Maria von Castel Durante', *Pantheon* 2 (1928), pp. 435–445; 3 (1929), pp. 88–92.

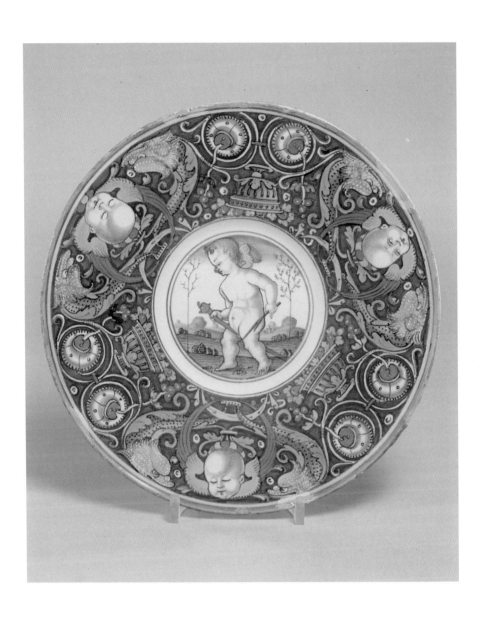

10 Broad-rimmed bowl, the 'Calumny of Apelles'
By Nicola da Urbino, Urbino, probably *c.* 1522

The scene is an allegory. On the right is a judge with over-long ears; before him Calumny, a young woman, accuses an innocent prisoner; at the back is naked Truth. Other figures represent vices such as Ignorance, Envy, and Deceit.

The Classical author Lucian described a painting by Apelles on the power of slander. Lucian's description was discussed by Alberti in his treatise on painting, and various Renaissance artists painted recreations of the subject. This version apparently makes use of a composition by Signorelli painted c. 1509 for the Petrucci Palace in Siena, but now lost; this may have been known to the painter through a collaborator on the Siena project, the Urbino-born artist Girolamo Genga, who came back to his home city following the return from exile of Duke Francesco Maria Della Rovere in 1521–2[1]. The bull represents Saint Luke, patron of painters[2].

This plate is a rare example of the early work of the key figure in the development of Urbino *istoriato,* who signed 'Nicola da Urbino' on five known pieces[3]. An old error long resulted in the supposition that his name was Nicolo Pellipario, but his real name was almost certainly Nicola di Gabriele Sbraga (or Sbraghe), a potter documented in Urbino between 1520 and his death in 1537–1538[4]. His extant work includes two sets which are among the loveliest achievements of maiolica: the earlier consists of seventeen pieces in the Correr Museum in Venice[5], the later, now scattered all over the world, was made around 1524 for Isabella d'Este[6]. This plate and one in Berlin[7] are similar to the Correr pieces and may have been part of the same set.

Maiolica; *bianco sopra bianco* around the well; the reverse plain. Diam: 27.9 cm.
Provenance: Given by C.D.E. Fortnum, 1896. Bought by Fortnum at the Pourtalès-Gorgier sale, Paris, 6 Feb.–21 March 1865, lot 49.
Bibliography:
Fortnum 1873, p. 485;
Burlington Fine Arts Club 1887, no. 167;
Fortnum 1896, pp. 180, 194, pl. XIV;
Fortnum 1897, pp. 72–73, no. C474;
B. Rackham, 'A New Work by Nicola Pellipario at South Kensington', *Burlington Magazine* 41 (1922), pp. 127–128, pl. IIB;
Rackham 1963, pl. 68;
J.V.G. Mallet, "A maiolica plate signed 'F.R.'", *Art Bulletin of Victoria* 1976, p. 17, fig. 7;
Mallet 1978, p. 400, pl. II;
Wilson 1987, no. 49.

[1] J.M. Massing, *Du texte à l'image, La Calomnie d'Apelle et son iconographie.* [forthcoming]. Cf. Wilson 1987, no. 50, for another version of the subject.
[2] I owe the suggestion that Saint Luke here appears as patron of painters to Creighton Gilbert.
[3] The signed pieces are in Leningrad (Kube 1976, no. 58), the Louvre (Wilson 1987, no. 59), a church in Novellara (Wilson 1987, no. 62), the Bargello (Ballardini 1933–1938, I, no. 228, pl. XXIX, fig. 338), and the British Museum (Wilson 1987, no. 63).
[4] F. Negroni, 'Nicolò Pellipario: ceramista fantasma', *Notizie da Palazzo Albani* 14 (1986), pp. 13–20.
[5] Illustrated by G. Papagni, *La maiolica del rinascimento in Casteldurante, Urbino e Pesaro* (Fano, n.d.).
[6] The set is listed by Rasmussen 1984, p. 160; see also J.V.G. Mallet, 'Mantua and Urbino: Gonzaga Patronage of Maiolica', *Apollo* 113 (1981), pp. 162–169, and M. Palvarini Gobio Casali, *La ceramica a Mantova* (Ferrara 1987), pp. 180–192.
[7] Hausmann 1972, no. 170.

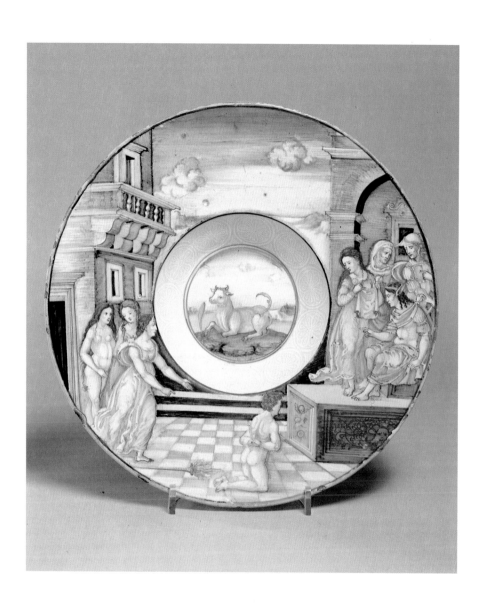

11 Dish on low foot, the Decollation of Saint John
 the Baptist
 Painted by an associate of Nicola da Urbino,
 probably lustred in the workshop of Maestro
 Giorgio Andreoli, Gubbio. Dated 1526

According to Matthew 14 and Mark 6, King Herod's wife, Herodias, had a grudge against John the Baptist for telling Herod the marriage was unlawful. Herod imprisoned John but did not put him to death. On Herod's birthday, Herodias' daughter (usually called Salome, though her name is not in the Bible) so enchanted the king with her dancing that he promised her any request she asked. Instigated by her mother, she replied 'Give me here John Baptist's head in a charger', and Herod, bound by his promise, had John beheaded.

The painter has set the scene in a Classicizing interior. A narrow border has the caption IO BATISSTA (John the Baptist). The painting is in the manner of Nicola da Urbino (see no. 10), and was believed by Fortnum to be by him. The balance of modern opinion, however, attributes it to an unidentified associate[1]. The arms in the border have not been certainly identified[2].

A number of *istoriato* pieces in the 'Urbino style' of the 1520s and 1530s have lustre and the mark of Maestro Giorgio. Some of these were painted in Gubbio by artists who went there to work for Giorgio; others, such as several by Francesco Xanto, were painted in Urbino, and seemingly (unless Giorgio had an 'out-station' in or near Urbino) carted to Gubbio to have lustre added in Giorgio's workshop. There is no good evidence how often this was done, or under what business arrangement.

Maiolica, with red and golden lustre; on the reverse, lustre scrolls and *1526 M° G° da ugubio* (Maestro Giorgio of Gubbio).
Diam: 27.5 cm.
Broken and repaired, with a small patch of make-up at the lower left edge of the *istoriato* scene and another on the rim at 5 o'clock.
Provenance: Given by C.D.E. Fortnum 1896. Purchased by Fortnum in Venice 'through the kind agency of Signor Lazari, then the assiduous and learned curator of the Correr Museum'.

Bibliography:
Robinson 1863, no. 5225;
Fortnum 1873, p. 199, no. 13;
Burlington Fine Arts Club 1887, no. 170;
Fortnum 1896, pp. 171, 193, and frontispiece; 'Marks and Monograms', p. 34, no. 102;
Fortnum 1897, pp. 69–70, no. C431;
Ballardini 1933–1938, I, no. 191, figs 182, 318;
B. Rackham, *Islamic Pottery and Italian Maiolica* (London 1959), p. 110;
B. Rackham, 'Italian Maiolica: New Light on Nicola Pellipario', *Keramikfreunde der Schweiz* 45 (1959). p. 23;
Mallet 1978, pp. 399–400, fig. 6.

[1] Similar border ornament is found on unlustred dishes in the Wallace Collection and the British Museum: Norman 1976, no. C41; Wilson 1987, no. 60.

[2] Fortnum identified the arms as those of Crivelli and Sforza of Milan, but if this was intended they are inaccurately drawn; the top and bottom shields may possibly be for Tambellini of Ferrara.

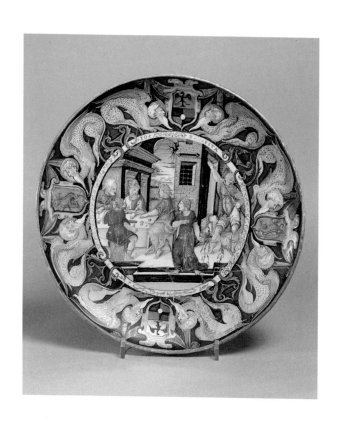

12 Dish on low foot, the Flight into Egypt
Castel Durante. Dated 1526

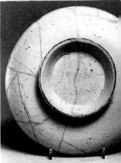

The small town of Castel Durante (pompously renamed Urbania by Pope Urban VIII in 1636), not far from Urbino, was one of the great pottery towns of the Renaissance; although the dominant centre of *istoriato* painting from about 1520 was the Ducal capital Urbino, Castel Durante probably remained quantitatively more productive, and some of the main figures in Urbino maiolica were *Durantini*, that is, from Castel Durante.

The artist of this plate made a habit in the years 1524, 1525, and 1526, of writing on the back of *istoriato* dishes, usually in the eccentric yellow used here, *In Castel Durante* and the date. Because of this, he is bluntly known as 'the "In Castel Durante" painter'. His unsophisticated figure drawing is balanced by a fine, cool sense of colour. His work outside the years of the dated dishes has not been positively identified[1].

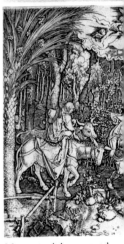

The subject, Mary and Joseph with the baby Jesus in flight towards Egypt to avoid the murderous intentions of King Herod, is from Matthew 2. The source of the composition is a woodcut by Albrecht Dürer, or more probably the close copy engraved by Marcantonio Raimondi[2]. Dürer's graphic work was extremely influential in Italy; it was particularly used as inspiration by maiolica-painters in the first quarter of the sixteenth century, before the Raphaelesque engravings of Marcantonio and his school became widely available and superseded it in popularity.

Maiolica; on the reverse in yellow: *1526 In Castel Durante.*
Diam: 26.8 cm.
Broken into several pieces and repaired.
Provenance: Fortnum Bequest, 1899. Previously in the collections of Prince Jérome Napoleon, sold at Christie's, London, 9–11 May 1872, lot 254; and Alessandro Castellani, sold in Paris, 27–29 May 1878, lot 187.
Bibliography:
A. Darcel and H. Delange, *Recueil de faïences italiennes de XVᵉ, XVIᵉ et XVIIᵉ siècles* (Paris 1869), p. 22, pl. 68;
Fortnum 1873, p. 294;
Burlington Fine Arts Club 1887, no. 173;
Fortnum 1896, p. 184, pl XV; 'Marks and Monograms', p. 51;
Fortnum 1897, p. 74, no. C507;
Ballardini 1933–1938, I, no. 184, figs 157, 321;
Rackham 1963, pl. 75A;
Mallet 1978, p. 401, fig. 7.

Marcantonio's engraved copy of a Dürer woodcut. Courtesy British Museum

[1] J.V.G. Mallet, 'Maiolica at Polesden Lacey: II', *Apollo* 92 (1970), pp. 340–342; Rasmussen 1984, p. 164. Most of the dated works are reproduced in Ballardini 1933–1938, I.
[2] Bartsch VII, p. 132, no. 89 (from the Life of the Virgin series); and XIV, p. 406, no. 634.

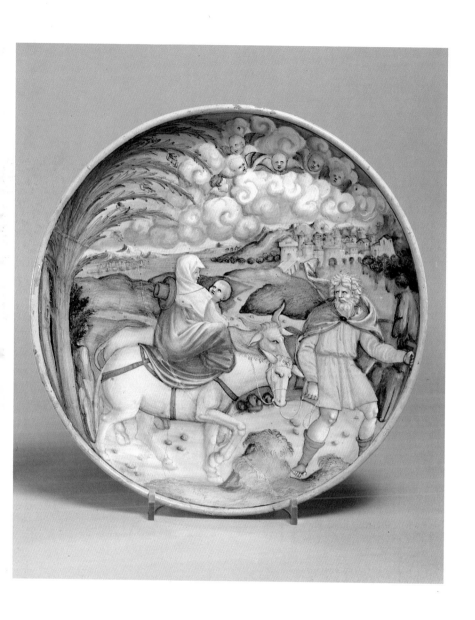

13 Dish on low foot, the Emperor Tiberius with Archelaus, King of Cappadocia
Attributed to the 'Milan Marsyas painter', Urbino, *c.* 1535

The style of this plate is close to work attributed to Nicola da Urbino around 1530–1535[1], but it is more probably by a painter known as the 'Milan Marsyas painter' (from a plate by him in the Castello Sforzesco Museum in Milan); this painter seems to have been active in Urbino around 1525–1535, where he worked in association with Nicola and with Xanto (see no. 16)[2].

The story illustrated is from Book 57 of the *Roman History* of Dio Cassius, a third-century A.D. historian. The Roman Emperor Tiberius summoned Archelaus, King of Cappadocia, to Rome on a charge of rebellion, and subsequently annexed Cappadocia as a province of the Roman Empire.

The composition is based on a small woodcut in an Italian translation of Dio Cassius, published in Venice in 1533[3]. Such small illustrations from cheap Italian translations or paraphrases of Classical authors were a favourite source for Urbino *istoriato* painters, though Dio Cassius is relatively infrequently used. It is not clear why the painter should have reversed the composition of the woodcut.

Maiolica; inscribed on the reverse *Chomo Tiberio fe tributaia tutta Lasia* (How Tiberius subjugated the whole of Asia).
Diam: 26.2 cm.
Repairs to rim.
Provenance: Given by C.D.E. Fortnum, 1888. Purchased by Fortnum at the sale of Ralph Bernal, Christie's, London, 5 March–30 April 1855, lot 2044.
Bibliography:
Burlington Fine Arts Club 1887, no. 152;
Fortnum 1896, pl. XIV;
Fortnum 1897, p. 75, no. C442.

[1] A plate with the same subject very similarly treated and with the same inscription was in the Scott-Taggart collection, sold Christie's, London, 14 April 1980, lot 21, where it was attributed, questionably, to Nicola.
[2] His work is defined and discussed by John Mallet, 'Xanto: i suoi compagni e seguaci', *Francesco Xanto Avelli da Rovigo. Atti del Convegno Internazionale di studi, Rovigo 1980* (Rovigo 1988), pp. 69–73.
[3] *Dione Historico delle Guerre & Fatti de Romani,* Venice 1533, fol. CCXLIIIr.

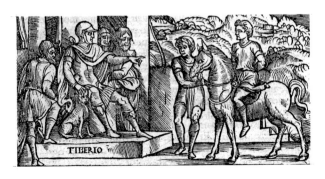

Courtesy British Library

34

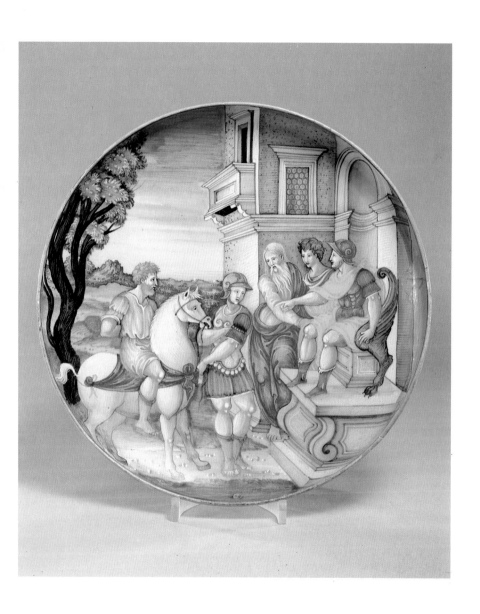

14 Dish, a ring of boys dancing
Perhaps made in the Urbino district, *c.* 1530–1535

The figures (some winged, some unwinged) are based on an engraving by the Bolognese engraver Marcantonio Raimondi after a design by Raphael[1]. Marcantonio had access to many of Raphael's drawings from about 1510 and established a flourishing business producing engravings from them, which he continued after Raphael's death in 1520. Through the engravings of Marcantonio and his associates, Raphael's designs became the dominant stylistic influence on *istoriato* maiolica, especially in the painter's home town Urbino, during the 1520s and 1530s. The elegant architectural background also echoes Raphael.

The talented painter of this dish has not been identified[2]. The style somewhat resembles Urbino work of around 1530, but the yellow and orange rings on the reverse are unusual for Urbino products.

Maiolica; on the reverse are two broad orange bands and narrow lines in yellow.
Dimensions: 24.8 cm.
Like many pieces of *istoriato* maiolica, this piece was once displayed in a frame; the edge and foot have been cut away to fit it in, and the present yellow edge is a restoration.
Provenance: Given by C.D.E. Fortnum, 1896. Bought (after 1857) by Fortnum from Count Gherardo Prosperi of Ferrara.
Bibliography:
Robinson 1863, no. 5208;
Fortnum 1873, p. 535;
Burlington Fine Arts Club 1887, no. 165;
Fortnum 1896, pp. 183-184; pl. XX;
Fortnum 1897, p. 88, no. C486;
Norman 1976, p. 113.

[1] Bartsch XIV, p. 177, no. 217. Other maiolica dishes from the same print are listed by Norman, *loc. cit.*
[2] Fortnum at one stage attributed the piece to the painter 'FR', but later rejected this view, probably rightly.

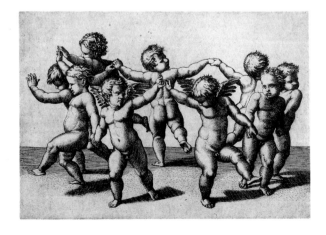

Courtesy
British Museum

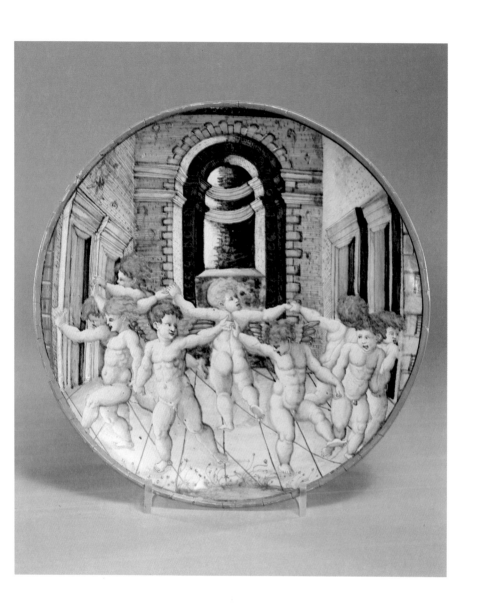

15 Plate, Hercules and the Hydra, from the Montmorency service
Workshop of Guido Durantino, Urbino 1535

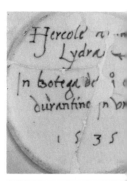

For the subject, see above, no. 8. On the left is Hercules with his club and lion skin; right, with a flaming torch, is his friend Iolaus. The figures, but not the architecture, are derived from an engraving made *c.* 1524 by Gian Jacopo Caraglio, after the Florentine artist Rosso Florentino; the engraving is one of a series of Hercules subjects[1].

The arms hanging from a tree, beneath a coronet, are for Anne de Montmorency, Grand Maître of France and the greatest private art patron of the French Renaissance. Nineteen pieces with mythological subjects are known of the set made for him in 1535, which was the most ambitious commission for *istoriato* maiolica yet made for a foreigner. Montmorency seems to have had a particular interest in pottery and was the principal patron of the great French potter Bernard Palissy.

The set was made in the pottery belonging to Guido Durantino (i.e. Guido from Castel Durante), later known as Guido Fontana. The workshop run by him in association with his son Orazio Fontana was the most important producer of *istoriato* maiolica in Urbino from the 1530s until at least 1570[2]. There is no evidence as to whether Guido himself painted maiolica.

Courtesy
British Museum

Maiolica, inscribed on the reverse *Hercole amazza Lydra. In Botega de M⁰ Guido durantino in Urbino 1535* (Hercules killing the Hydra. In the workshop of Master Guido Durantino in Urbino).
Diam: 30.8 cm.
Broken into several pieces and restored.
Provenance: Fortnum Bequest, 1899. Previously in the collections of Louis Visconti, sold Paris, 13–16 March 1854, lot 9; Prince Jérome Napoleon, sold Christie's, London, 9–11 May 1872, lot 253; and Alessandro Castellani, sold Paris, 27–29 May 1878, lot 270.

Bibliography:
A. Darcel and H. Delange, *Recueil de faïences italiennes de XVᵉ, XVIᵉ et XVIIᵉ siècles,* Paris 1869, pp. 9, 22, pl. 72;
Fortnum 1873, p. 335;
Burlington Fine Arts Club 1887, no. 175;
Fortnum 1896, p. 202. pl. XV; 'Marks and Monograms', p. 56;
Fortnum 1897, p. 75, no. C508;
Ballardini 1933-1938, II, no. 205, figs 202, 358;
F. Liverani, *Le maioliche della Galleria Estense di Modena* (Faenza 1979), p. 44;
J.V.G. Mallet, 'In Botega di Maestro Guido Durantino in Urbino'. *Burlington Magazine* 129 (1987), p. 296, no. 9;
E.A. Carroll, *Rosso Fiorentino: Drawings, Prints, and Decorative Arts,* exhib. cat., National Gallery of Art, Washington, 1987, no. 15.

[1] Bartsch XV, pp. 85–86, no. 46; Carroll, *op. cit.* 1987, no. 11.
[2] Mallet, *op. cit.* 1987 is a full account of Guido and his workshop.

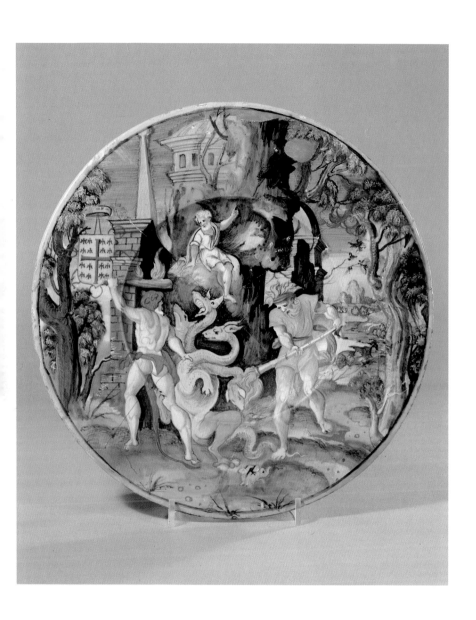

16 Plate, Xerxes fleeing from Greece
By Francesco Xanto Avelli, Urbino. Dated 1537

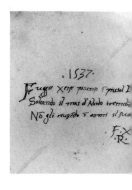

This large plate is an imposing example of the work of the most interesting and eccentric character in the history of Renaissance maiolica: Francesco Xanto Avelli came from Rovigo, near Padua, and settled in Urbino by 1530, where, between 1530 and 1542, he painted a stream of works, which he signed and dated more regularly than any other maiolica-painter. He seems to have been a specialist painter, rather than a workshop-owner like Nicola da Urbino and Guido Durantino.[1]

Xanto aspired to be a man of culture and a poet (his sonnet sequence written in praise of Francesco Maria Della Rovere, Duke of Urbino, survives among the manuscripts in the Vatican). His choice of subject matter is ambitious, including allegories of contemporary politics and subjects from Classical history.

The story depicted here is the flight of the Persian King Xerxes in a fishing boat back to Asia after the defeat of his invasion of Greece in 480 BC. The source was the abbreviated version by Justin of the Universal History by the Roman writer Trogus Pompeius; Justin was widely read in the Renaissance and available in Italian translation[2]. The plate probably formed part of a large scale Persian War series[3]. The terza rima verses may be Xanto's own.

In a 'scissors-and-paste' manner characteristic of Xanto, the elaborate composition is built up out of single figures taken and sometimes bizarrely adapted from engravings, mainly those of Marcantonio Raimondi and his associates. At least four engravings and a woodcut have been drawn upon for figures on the plate[4].

Maiolica, signed on the reverse, F.X..R. (Francesco Xanto of Rovigo) and inscribed:
Fuggie Xerse pauroso î picciol Legno
Solcando il mar d'Abido tremebôdo
Nô gli reuscêdo î armi il suo disegno.
(Xerxes in fright flees in a small boat, cleaving his way trembling through the Sea of Abydos after the failure in battle of his project.)
Diam: 40.5 cm.
Broken and repaired; small patches of in-paint.
Provenance: Given by C.D.E. Fortnum, 1888. Bought (after 1857) by Fortnum from Count Gherardo Prosperi of Ferrara.
Bibliography:
Robinson 1863, no. 5249;
Burlington Fine Arts Club 1887, no. 172;
Fortnum 1896, pl. XVI;
Fortnum 1897, p. 77, no. C448;
T. Borenius, *Catalogue of a Collection of Pottery belonging to W.H. Woodward* (London 1928), p. 34.

[1] For the large specialist literature on Xanto, see Wilson 1987; F. Cioci, *Xanto e il Duca di Urbino* (Milan 1987); *Francesco Xanto Avelli da Rovigo. Atti del Convegno Internazionale di studi, Rovigo 1980* (Rovigo 1988).
[2] Justin, *Epitoma Historiarum Philippicarum Pompei Trogi*, II, 13.
[3] A plate lost in World War II from the Herzog Anton Ulrich-Museum in Brunswick showed the battle of Thermopylae, with the same date and similar *terza rima* verses on the back, Lessmann 1979, p. 566, no. IX; cf. *ibid.* p. 171, for a series of panels by Xanto with Persian subjects (1536). Another 1537 plate with a Xerxes subject was sold at Sotheby's, London, 21 November 1978, lot 18.
[4] Bartsch XIV, p. 12 no. 10; p. 89, no. 104, no. 117; XV, p. 89, no. 53; and the 'Luna' woodcut from the planets series signed *GGF*, F. Lippmann, *The Seven Planets* (International Chalcographical Society, 1895), no. Fvii.

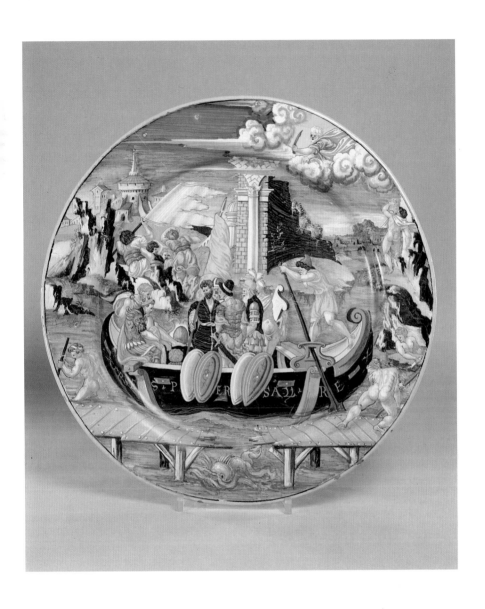

41

17 Shallow bowl on low foot, the Fall of Phaethon
By Francesco Durantino, Urbino or Monte
Bagnolo, *c*. 1545–1550

In Greek mythology, Phaethon, the son of the Sun-God
Phoebus, induced his father to let him ride in the chariot
of the Sun. When he proved unable to control it, he was
hurled from the chariot to his death. On the right,
Phaethon is shown begging his father for the favour. The
composition is taken from a simple woodcut in an
illustrated edition of Ovid's *Metamorphoses,* a book
which was very popular in the Renaissance[1]; similar
woodcuts were used in numerous editions from 1497
onwards, and it is difficult to say which edition the
painter used.

With its fluid touch, elegant architecture, and
exaggerated musculature, the plate is a characteristic
work by Francesco Durantino (i.e. Francesco from Castel
Durante), one of the most prolific of Urbino *istoriato*
maiolica painters in the 1540s. His career is relatively
well-mapped thanks to marked pieces and references to
him in local archives[2]. In 1543–44 he was working in the
workshop of Guido di Merlino in Urbino, and from 1547
to about 1554 ran a small pottery at Monte Bagnolo, on
the outskirts of Perugia. This dish could have been made
in either place.

Maiolica, inscribed on the reverse *d[i] Phetonte* (of Phaethon),
followed by a squiggle of unclear meaning.
Diam: 28.4 cm.
Retouchings to rim.
Provenance: Given by C.D.E. Fortnum, 1888.
Bibliography:
Burlington Fine Arts Club 1887, no. 154;
Fortnum 1897, p. 78, no. C451;
Mallet 1978, p. 402, fig. 8.

[1] Wilson 1987, p. 113.
[2] His work will be discussed
in detail in my forthcoming
section on 'Renaissance
Ceramics' for the
Systematic Catalogue of
the National Gallery of
Art, Washington.

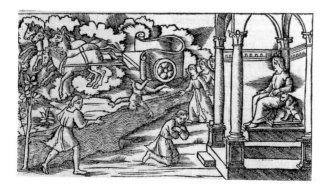

Woodcut from an Italian
verse edition of Ovid's
Metamorphoses,
published in Venice in
1533. This or a similar
edition provided
Francesco with the outline
of the composition. (By
courtesy of the British
Library Board.)

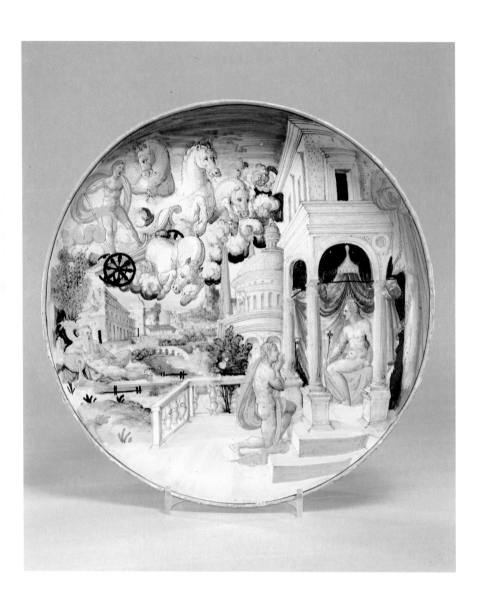

18 Plate, the bull of Perillus
Attributed to the workshop of Guido di Merlino, Urbino, *c.* 1540–1550

The subject is the Classical story of Phalaris, the brutal tyrant of Agrigentum in Sicily, who commissioned from the inventor Perillus a novel instrument of torture in the form of a bronze bull in which to roast his enemies alive; the bull was so designed that the screams of its victims sounded like the bull roaring. When it was finished, Phalaris aptly made Perillus its first victim. The story was widely known in the Renaissance through the collection of moral stories from ancient history by Valerius Maximus, which was available in Italian and widely read[1]. The 'bull of Perillus' was one of the favourite maiolica subjects.

The arms are those of the Augsburg families Hörwarth and Schellenberg, and the plate forms part of a set probably made for Johannes Hörwarth and Helen Schellenberg, who had married in 1528. The affluent merchant families of Augsburg and Nuremberg, which carried on intensive trading activity with Italy, began commissioning sets of maiolica with their arms by about 1515 and went on doing so throughout the sixteenth century.

The set of which this plate formed part has been convincingly attributed to the workshop of the Urbino potter Guido di Merlino[2], where Francesco Durantino was also working in the 1540s. Thirteen other pieces with the arms are recorded, including three in the Victoria and Albert Museum[3].

Maiolica, inscribed on the reverse *Novû tormêti genus a Perillo invêtû* (a new type of torture invented by Perillus).
Diam: 28.3 cm.
Some rim chips. The glaze has crawled in the kiln in patches.
Provenance: J. Francis Mallett Bequest, 1947 (no. M263).

[1] Valerius Maximus, IX, ii, 9.
[2] Lessmann 1979, p. 178. For Guido di Merlino, see *ibid.,* p. 175.
[3] Lessmann 1979, pp. 178–179, lists the known pieces; her no. 155 incorporates a group of figures identical to that on the Oxford plate.

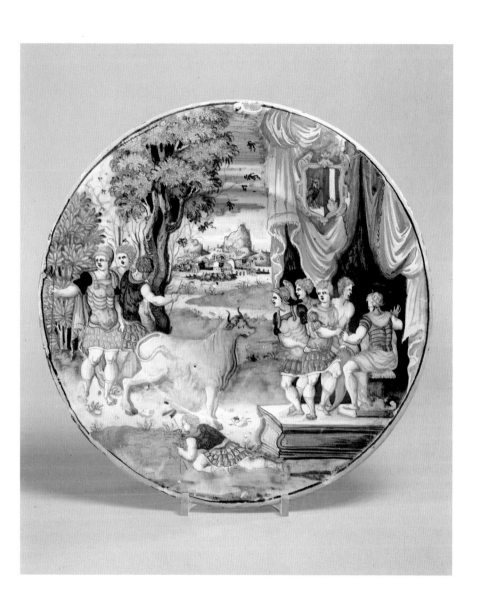

19 Plate, Saint Luke
Urbino, 1543

The subject is Saint Luke the Evangelist, accompanied by the emblem traditional in medieval iconography, a bull (compare no. 10).

Other pieces marked in the same handwriting in the Ashmolean Museum[1], in the Victoria and Albert Museum[2], and at Erddig (Wales)[3] are dated 1543 and marked with a letter P. The Victoria and Albert plate is apparently the work not of this painter but of Francesco Durantino (see no. 17), so the two painters were perhaps active in the same workshop. Francesco is known to have been working in 1543 in the workshop of Guido di Merlino (compare no. 18), and it may be that this piece is a product of the same workshop. Both the P on the other plates and the hard-to-decipher inscription on this plate are likely to be signatures of the painter.

Maiolica, inscribed in the reverse *1543 San Luca in Urbin p:*teo [?] [4] *F*co.
Diam: 25 cm.
Cracked; rim chips.
Provenance: Given by C.D.E. Fortnum., 1888. Bought by Fortnum from Delange, Paris, in 1854.
Bibliography:
Fortnum 1873, p. 370, no. 37;
Burlington Fine Arts Club 1887, no. 151;
Fortnum 1896, 'Marks and monograms', p. 70, no. 220;
Fortnum 1897, p. 78, no. C450;
J.V.G. Mallet, 'Pottery and Porcelain at Erddig', *Apollo* 108 (1976), p. 42.

[1] From the J. Francis Mallett Bequest in 1947, no. M264, and previously in the Fountaine collection, sold Christie's, London, 16–19 June 1884, lot 183. The subject is Abraham washing the feet of the three angels. In addition to the inscription and date, the plate has a spurious later inscription *il Sarmoneta F.*
[2] Rackham 1940, no. 859.
[3] Mallet, *op. cit.* 1976, pp. 43, figs 5 and 6; Mallet mentions a fifth plate similarly marked.
[4] The writing is unclear and the superscript letters could be *tto, tte,* or *teo.*

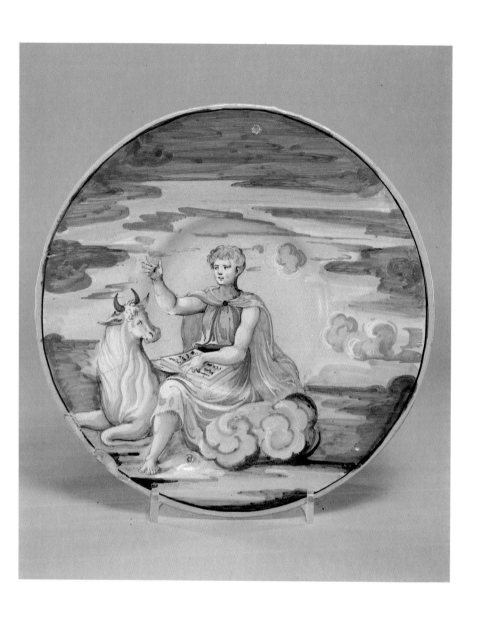

20 Dish on low foot, God creating the animals
Workshop of Girolamo di Lanfranco, Pesaro.
Dated 1540

There were close links between the potteries of Pesaro,
Urbino, and Castel Durante throughout the Renaissance
and they are sometimes collectively called the 'Metauro
school' after the river which runs through the district.

Despite having what seems to be different hand-
writing on the back, this dish is probably (partly if not
wholly) by the same painter as a dish of crucial
documentary importance given by Fortnum to the
British Museum in 1888, which is marked as made in the
workshop of Girolamo di Lanfranco dalle Gabicce in
Pesaro in 1544[1]. Girolamo's workshop was the most
important producer of *istoriato* maiolica in Pesaro,
particularly in the 1540s. 1540 is the earliest date found on
any marked piece of Pesaro maiolica. Fortnum thought
the dish: 'an unattractive but important piece'.

The composition, illustrating Genesis 1, is adapted
from an engraving by an associate of Marcantonio after
Raphael's design for the Vatican Loggias, painted in the
years before Raphael's death in 1520[2]. Fortnum noted the
delicious absurdity of the conventionalized town in the
landscape of a Creation scene.

Maiolica, inscribed on the reverse with a confused inscription
Chriavite animallis Christtus fatto in pesaro (Creation of the animals
Christ. Made in Pesaro).
Diam. 26.6 cm.
Broken and repaired.
Provenance: Given by C.D.E. Fortnum, 1888. Bought (after 1857) by
Fortnum from Count Gherardo Prosperi of Ferrara.

Bibliography:
Fortnum 1873, pp. 157, 164, no. 3;
Fortnum 1896, p. 149, pl. XI; 'Marks and Monograms', p. 23, no. 67;
Fortnum 1897, p. 64, no. C418;
Rackham 1940, p. 305;
P. Berardi, *L'antica maiolica di Pesaro* (Florence 1984), pp. 189–190,
fig. 96;
R. Gresta, 'Alcune "historie" della bottega di Girolamo dalle Gabicce',
Notizie de Palazzo Albani 12 (1983), p. 156, fig. 2;
P. Bonali and R. Gresta, *Girolamo e Giacomo dalle Gabicce maiolicari
a Pesaro nel secolo XVI* (Rimini 1987), pp. 44–45, Tav II.

[1] Wilson 1987, no. 96; Bonali
and Gresta, *op. cit.* 1987,
pp. 42–43, tav. I.
[2] Bartsch XV, p. 5, no. 1.

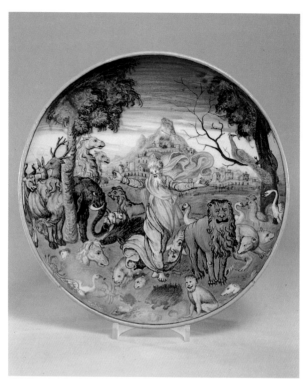

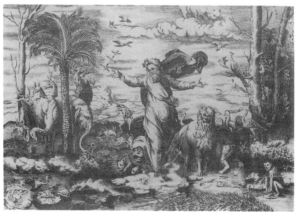

21 Dish on low foot, 'Ierolima bella'
Probably Urbino district (Castel Durante?),
c. 1535–1545

One of the most common and charming products of the Renaissance Italian potteries, particularly in the Urbino district from about 1520 onwards, are the so-called 'belle donne' dishes, painted with a head of a woman, usually accompanied by a name and an adjective like 'bella' (beautiful), 'graziosa' (charming), or 'diva' (divine)[1]. The features of these women are usually so standardized that it would be misleading to describe them as portraits. Some of them were presumably made for young men to give as gifts to their girl-friends; others may have been purely decorative, and the frequency of rather high-flown and Classicizing names recalls those in the conventional tributes of Renaissance sonnets.

Maiolica, the reverse plain.
Diam: 22.7 cm.
Provenance: Given by C.D.E. Fortnum, 1888. Bought by Fortnum at Fürth (near Nuremberg), 1856.
Bibliography:
Burlington Fine Arts Club 1887, no. 159;
Fortnum 1897, p. 78, no. C452.

[1] For examples, see Giacomotti 1974, pp. 243–249; Wilson 1987, pp. 144–148.

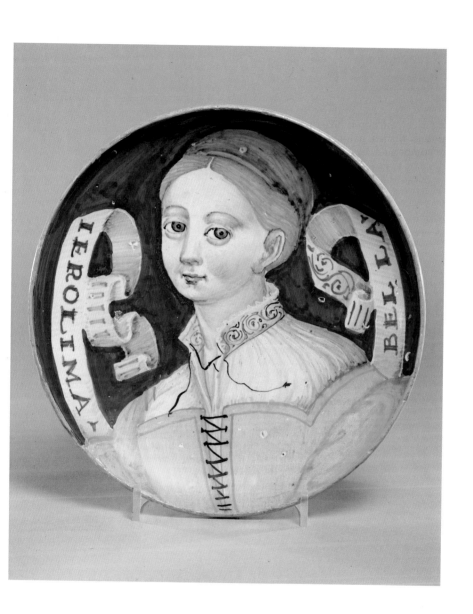

22 Storage jars (albarelli)
Castel Durante, c. 1550–1560

Several pharmacy jars more or less similar to these are marked as made in Castel Durante, and one at Sèvres is apparently dated 1555[1]. Some at least of them look likely to be from the same workshop as a jar in a private collection in Italy which is marked as made in Castel Durante in 1562 by 'Maestro Simone' – probably a recorded Castel Durante potter named Simone da Colonnello[2].

The decoration, incorporating trophies of arms and music, portrait medallions, foliage, grotesques in grisaille, and scrolling ribbons scratched out of the blue ground, is a compendium of Castel Durante motifs of the period. The treatise compiled by Cipriano Piccolpasso of Castel Durante around the same time includes pattern-drawings of this kind of ornament.

The Sicilian provenance of the jars is interesting in view of documentary records that in 1548–1550 a group of Castel Durante potters contracted to supply several hundred vessels to a Genoese merchant resident in Palermo; a similar order from Palermo in 1562 was for four hundred pharmacy jars[3]. While surviving pieces cannot be proved to have formed part of these orders, it is a measure of the success of the Castel Durante industry that it was supplying markets as far afield as Sicily on a large scale. The documentary evidence is that large orders were shared or sub-contracted: if several potteries were making pieces to a single pattern, attribution on the basis of the rare marked pieces is decidedly hazardous.

Maiolica, tin-glazed inside and out.
Height: 28.7 and 29.3 cm.
Previously mounted by Fortnum in gilt-metal for use as lamps.
Provenance: Given by C.D.E. Fortnum, 1888. Bought by Fortnum in 1854 from Signol, a Paris dealer, and stated to have come from a pharmacy in Sicily.
Bibliography:
Burlington Fine Arts Club 1887, nos. 147 and 149;
Fortnum 1896, p. 184;
Fortnum 1897, p. 73, no. C437 and C438;
Giacomotti 1974, p. 241.

A drawing from the manuscript of *The Three Books of the Potter's Art*, by Cipriano Piccolpasso, c. 1557, showing 'trophies' and 'arabesques'. Victoria and Albert Museum.

[1] Giacomotti 1974, no. 794–796; Rackham 1940, no.615; Wilson 1987, no. 128; others are in the Royal Museum of Scotland and the Fine Arts Museums of San Francisco. For the attribution, cf. Bojani *et al.* 1985, nos. 306, 307.
[2] Best illustrated in the sale catalogue, *Maioliche rinascimentali italiane*, Semenzato, Milan, 5 November 1986, lot 116. A comparable series with *istoriato* decoration is attributed to a possibly non-existent potter, Andrea da Negroponte: R.E.A. Drey, 'Pots de pharmacie du duché d'Urbino à décor dit "istoriato"', *Revue d'histoire de la pharmacie*, March 1985, XXXII, pp. 5–12; and Sept. 1987, XXXIV, pp. 195–200; cf. Wilson 1987, no. 89.
[3] A. Ragona, 'Maioliche casteldurantine del sec. XVI per un committente siculo-genovese', *Faenza* 62 (1976), pp. 106–109; Leonardi 1982, pp. 164–168.

53

23 Armorial plate
Faenza, c. 1524

The arms are those of the Altoviti and Soderini families of Florence, and the plate formed part of a set probably made for Bindo Altoviti and his wife Fiammetta Soderini, who were married in 1511. Altoviti was a successful Florentine financier and art patron, who spent much of his life in Rome and was an inveterate opponent of the Medici. A piece from the same set formerly in the Adda collection is dated 1524[1].

In the 1520s and early 1530s a Faenza pottery (or potteries) made a series of armorial sets in this style for Florentine clients, including great families like the Strozzi, Guicciardini, and Salviati[2].

The bluish glaze and border decoration, with scroll-work ending in dolphin-heads, cornucopias, and cherub-heads, is characteristic of Faenza work of the 1520s and early 1530s; so is the decoration of fern-scrolls in white on a blue ground around the well. The matt dark red used on the arms was another Faenza characteristic: red was a notoriously difficult colour for Renaissance maiolica workshops, and is rarely found outside Faenza and Tuscany. On the reverse is a mark that occurs commonly on work of this type and seems likely to be meant to represent an inflatable ball; this used to be thought the workshop mark of a Faenza workshop called the Casa Pirota, but this is unlikely; its exact significance remains to be discovered, and it may not even be a workshop mark at all[3].

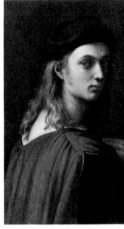

Maiolica, painted on a greyish-blue (*berettino*) glaze.
Diam: 24.8 cm.
Provenance: Fortnum Bequest, 1899. Bought by him at the H.G. Bohn sale, Christie's, London, 29–30 May 1876, lot 174.
Bibliography:
Burlington Fine Arts Club 1887, no. 155;
Fortnum 1896, pl. XVIII;
Fortnum 1897, p. 85, no. C475.

Raphael: *Bindo Altoviti*
National Gallery of Art,
Washington

[1] B. Rackham, *Islamic Pottery and Italian Maiolica* (London 1959), no. 308; another is illustrated in S. De Ricci, *Early Italian Maiolica in the Collection of Mortimer L. Schiff* (New York 1927), no. 98.
[2] For example Rackham 1940, nos 285, 290; Wilson 1987, nos 45, 202, 113.
[3] Norman 1976, pp. 103–108.

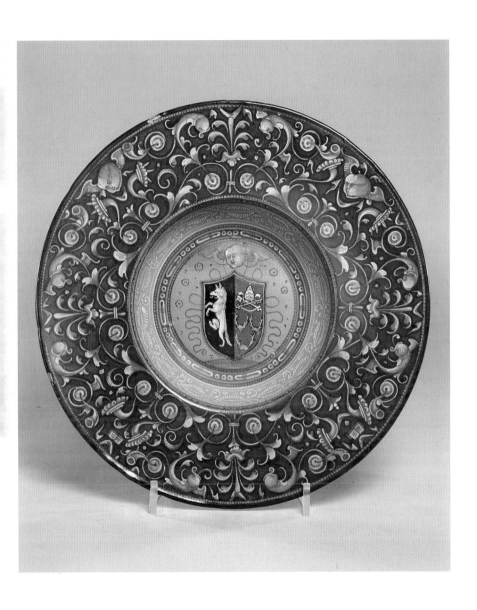

24 Shallow bowl on low foot, the Triumph of Time
By Baldassare Manara, Faenza, c. 1530–1535

The subject is taken from one of the favourite of all literary sources for Renaissance works of art, the *Trionfi* (Triumphs) of Petrarch, written in the mid-fourteenth century[1]. Time is shown in his chariot, pulled by stags, and accompanied by a crowd, among whom Hercules is prominent on the left. The figure of Time is derived, directly or indirectly, from a late fifteenth-century Florentine engraving [2].

This dish is one of the finest works of Baldassare Manara, one of the few Faenza *istoriato* painters with a definable artistic personality whose name is known. He is documented from 1526 until his death in 1546 or 1547, but his only dated signed works are dated 1534, 1535, and 1536[3]. Thanks to Fortnum, the Ashmolean has the best group of his work anywhere, including another signed work with Caesar receiving the head of Pompey, and an unsigned dish with Alexander and Diogenes[4].

Courtesy British Museum

Maiolica, signed on the reverse *Baldasara manara fañ* (for *faentino,* 'of Faenza').
Diam: 27.8 cm.
Restorations to rim. There is a firing fault just below the centre.
Provenance: Fortnum Bequest, 1899. Bought by Fortnum at Fürth 1856. Previously in the collection of Dr Marchini, Parma.

Bibliography:
P. Zani, *Enciclopedia metodica critico-ragionata delle belle arti* (Parma 1817–1824), part I, vol, 12, p. 317;
Robinson 1863, no. 5187;
Fortnum 1873, pp. 482, 495, no. 16;
Burlington Fine Arts Club 1887, no. 156;
Fortnum 1896, p. 264, pl. XIX; 'Marks and Monograms', p. 105, no. 336;
Fortnum 1897, p. 87, no. C482;
Rackham 1940, p. 263;
Mallet 1978, p. 404.

[1] V. Masséna, Prince d'Essling, and E. Müntz, *Pétrarque, ses études d'art, son influence sur les artistes* (Paris 1902).
[2] A.M. Hind, *Early Italian Engraving* (London 1938–1948), I, p. 134, no. B.II.5; III, pl. 195; cf. *ibid.,* I, pp. 33–35, 131.
[3] The signed pieces are listed by Wilson 1987, p. 70.
[4] The Caesar and Pompey is Fortnum 1897, no. C483; illustrated Mallet 1978, pp. 403–404, fig. 11. The Alexander and Diogenes is Fortnum 1897, p. 88, no. C484 (not illustrated). Fortnum's attribution of a fourth plate (Fortnum 1897, p. 88 no. C485), with Christ raising the paralytic, is less convincing.

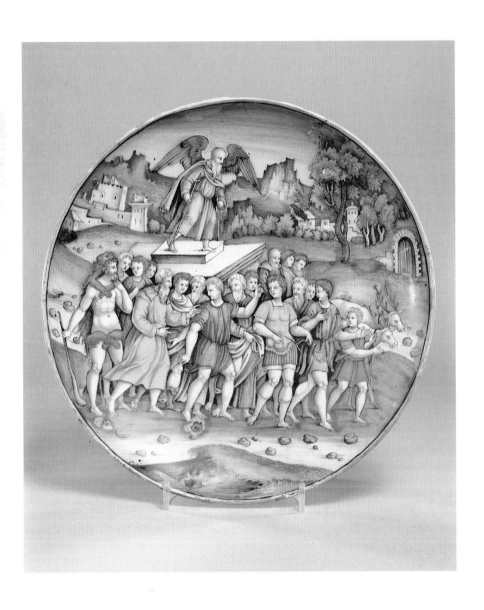

25 Plate, a Siren, with a mirror and horn
Venice, dated 1540

Venice stands rather apart from the rest of Italy in its Renaissance maiolica[1] as it does also in many other arts. This splendid dish is the earliest dated example of a characteristic type of Venetian maiolica, painted mainly in blue, with highlights in white, on a greyish blue ground known as *berettino*, and ornamented on the reverse with a garland. A plate in the same style in the Victoria and Albert Museum[2] is marked as made in the workshop of 'Maestro Lodovico' in Venice, and it is possible, though not certain, that the Oxford plate was made in the same workshop. Nothing is known of Maestro Lodovico.

Maiolica, painted in blue and white on a greyish blue glaze.
The reverse has imitation fluting in imitation of embossed metalwork, and a blue garland, and is inscribed: *1540 ADI.16.DEL MEXE DE OTV...* (On 16 October 1540); the remainder is spoilt by crawling of the glaze.
Diam: 37.2 cm.
Provenance: Given by C.D.E. Fortnum, 1888. Bought by Fortnum from Bruschetti, Milan, 1862.
Bibliography:
Robinson 1863, no. 5216;
Fortnum 1873, p. 588;
Burlington Fine Arts Club 1887, no. 174;
Fortnum 1896, p. 301, pl. XXI; 'Marks and Monograms', p. 123, no. 398;
Fortnum 1897, p. 90, no. C492;
B. Rackham, *Victoria and Albert Museum: Guide to Italian Maiolica* (London 1933), p. 70;
G. Morazzoni, *La maiolica antica veneta* (Milan 1955), pl. 11;
G. Liverani, *La maiolica italiana* (Milan 1958), p. 44, fig. xxxv;
Rackham 1963, pl. 79.

[1] A. Alverà Bortolotto, *Storia della ceramica a Venezia dagli albori alla fine della Repubblica* (Florence 1981); T. Wilson, 'Maiolica in Renaissance Venice', *Apollo* 125 (1987), pp. 184–189, with further references.
[2] Rackham 1940, no. 960.

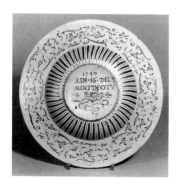

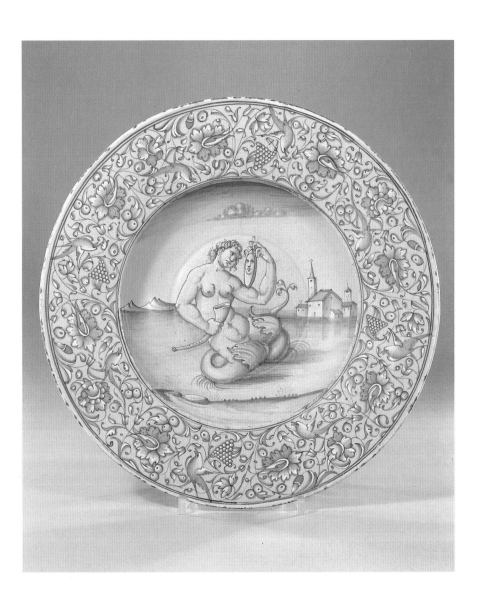

26 Shallow basin, a banqueting scene
Attributed to Domenego da Venezia, Venice,
c. 1560–1570

From the 1540s Venice produced a good deal of *istoriato* maiolica in a style influenced by the Urbino school. Although Fortnum attributed this dish to Urbino, the shape, colouring reminiscent of Veronese, and characteristic yellow lines on the back suggest that this dish is Venetian, and from one of the most prolific workshops in Venice in the third quarter of the sixteenth century, associated with the name of Domenego da Venezia. A number of plates and pharmacy jars from the 1560s are marked as 'made' by Domenego, but it is not certain whether he was the owner of the workshop where he worked, or an employee. In a document of 1547 he is described as *depentor over bochaler* (painter or rather potter), so he was certainly a pottery painter and may possibly also have been a painter in other media[1].

The identification and influence of Venetian Renaissance maiolica is still a subject only vaguely mapped out. The immense power of Venice in European trade in the sixteenth century meant that the 'Venetian connection' was of decisive importance in the spread of Italian maiolica to form the basis of tin-glaze pottery traditions in the Low Countries and thence in England[2].

Fortnum thought the subject was a scene from the story of the Prodigal Son. No engraved source for the composition has yet been found.

Maiolica; concentric yellow lines on the reverse.
Diam: 29.5 cm.
Broken and repaired.
Provenance: Given by C.D.E. Fortnum, 1888. Bought by Fortnum at the sale of Ralph Bernal, Christie's, London, 5 March–30 April 1855, lot 2023.
Bibliography:
Fortnum 1897, p. 81, no. C463.

[1] On Domenego, see Lessmann 1979, p. 409; E. Concina, 'Un contributo alla definizione della cronologia ed all'ambiente di Maestro Domenico da Venezia', *Faenza* 61 (1975), pp. 136–139; M.P. Pavone, 'Maestro Domenico da Venezia e la spezeria del grande ospedale di Messina', *Faenza* 71 (1985), pp. 49–67; A. Alverà Bortolotto, *Storia della ceramica a Venezia dagli albori alla fine della Repubblica* (Florence 1981), pp. 16, 88–92.
[2] T. Wilson, 'Maiolica in Renaissance Venice', *Apollo* 125 (1987), pp. 184–189, with further references; A. Alverà Bortolotto, 'Un pavimento maiolicato ordinato a un veneziano nelle Fiandre nel 1532', *Faenza* 73 (1987), pp. 22–31.

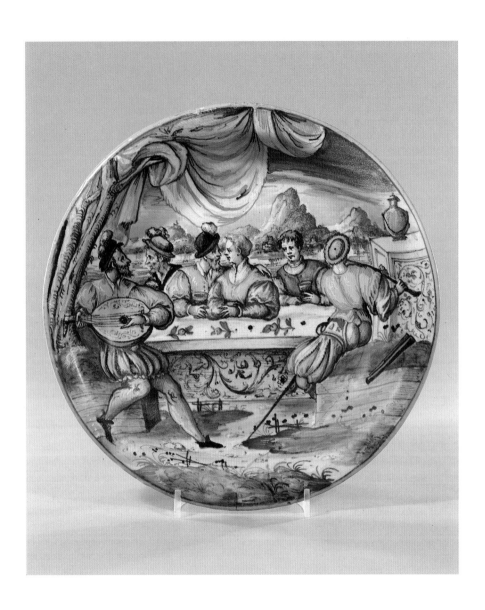

61

27 Plate, the heroism of Mucius Scaevola
Gagliano, near Florence, 1547

The crossed *SP* is the mark used at a famous small factory situated in the outbuildings of the villa at Cafaggiolo, north of Florence. The Cafaggiolo factory was founded by potters from Montelupo (a major pottery centre on the Arno down river from Florence) in 1498 and in the following half century the family-run pottery produced some of the most striking of all Renaissance maiolica. This plate is the work of an undistinguished painter who also signed '.A.f.' (the 'f' probably for 'fecit') on several plates marked as made in Cafaggiolo[1]. This plate and one in the Bargello in Florence painted by a different hand are the sole evidence of production in the nearby village of Gagliano[2].

The story is one of the famous episodes of ancient Roman heroism made popular in the Renaissance by Valerius Maximus (III,iii,1). When Porsenna, King of the Etruscans, brought an army against Rome, Scaevola went out to try to assassinate him. When he did not succeed, he put his hand into a flame and let it burn, to show his contempt for pain. Porsenna was so impressed that he let him go free[3]. The irrelevant landscape-and-animal border is unusual and charming.

Maiolica; marked on the reverse with *SP* in monogram (the P crossed) and a small *G, in gAliano Nellano 1547* (in Gagliano in the year 1547) and *.A.f*[t].
Diam: 39.3 cm.
Reconstructed from fragments.
Provenance: Given by C.D.E. Fortnum, 1888. Bought by him at the sale of Auguste Ricard de Montferrand of Saint Petersburg, Christie's, London, 14–16 November 1859, lot 352.
Bibliography:
Aperçu sur l'art céramique italienne. Collection de Mr *A. de Montferrand* (Saint Petersburg 1854), p. 14, no. 106;
Robinson 1863, no. 5217;
Fortnum 1873, pp. 94, 102, no. 16;
Burlington Fine Arts Club 1887, no. 179;
A. Darcel, 'La céramique italienne d'après quelques livres nouveaux', *Gazette des beaux-arts,* 3rd series, 9 (1893), pp. 120–121;
Fortnum 1896, p. 133, pl. X; 'Marks and Monograms', p. 14, no. 39;
Fortnum 1897, p. 60–61, no. C410;
C. Guasti, *Di Cafaggiolo e d'altre fabbriche di ceramiche in Toscana* (Florence 1902), pp. 251–254;
Rackham 1940, p. 316;
Mallet 1978, p. 403, fig. 9;
G. Cora and A. Fanfani, *La maiolica di Cafaggiolo* (Florence 1982), no. 141;
Join-Dieterle 1984, p. 68;
A. Alinari, *Maioliche marcate di Cafaggiolo* (Lo Specchio del Bargello 43, Florence 1987), p. 35.

[1] Cora and Fanfani 1982, cited above, nos. 90, 103, 109, 129; and one with Diana and Actaeon described but not illustrated in W.B. Honey, *A Catalogue of the Collection of Italian and other Maiolica ... formed by William Ridout* (London 1934), p. 19, no. T29. The small 'G' after the 'SP' monogram is of uncertain significance.
[2] The Bargello plate has the SP mark and the words *agagliano fatto A1552* (made at Gagliano 1552): Alinari 1987 (cited above), pp. 39–43.
[3] No graphic source for the composition has been found, but it seems to echo a drawing in a sketchbook in Lisle attributed to Jacopo Ripanda, other drawings of which were used by maiolica painters; cf. B. Jestaz, 'Les modèles de la majolique historiée, bilan d'une enquête', *Gazette des beaux-arts* 72 (1972), pp. 217–222.

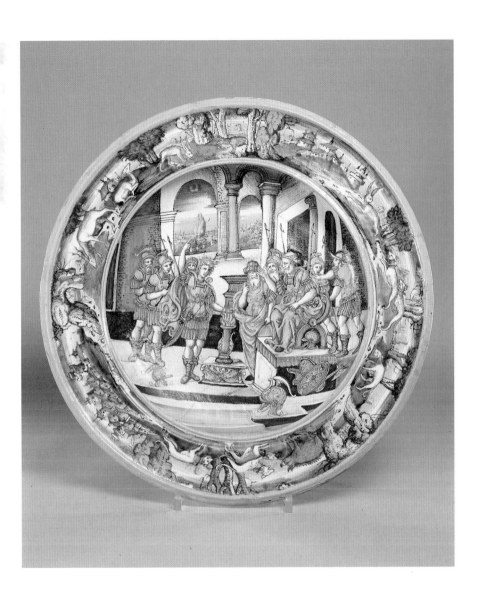

28 Flat dish on high foot
Probably Patanazzi workshop, Urbino,
c. 1580–1600.

The decoration, on a whitened ground, incorporates human figures, winged monsters, vases and imitation cameos. Decoration of this sort became fashionable in Renaissance Italy after the rediscovery about 1480 of the fantastic painted decorations of the *Domus Aurea,* the great palace in Rome built for the Emperor Nero (died 68 AD). The underground chambers where these wall and ceiling paintings were found were called by the people of Rome *grotte* (caverns); the paintings were therefore called *grottesche,* whence our word 'grotesque'[1]. The most influential Renaissance recreation of white-ground *grottesche* was the decoration in the Vatican Loggias, carried out under Raphael's direction by Giovanni da Udine about 1519. White-ground grotesque decoration was introduced into maiolica in Raphael's native Urbino considerably later, perhaps not before 1560, and became increasinlgy popular as the century went on. The main exponents were the workshop of Guido Durantino and/ or his son Orazio Fontana, and their successors the Patanazzi, who continued to produce maiolica in this style into the seventeenth century. The decoration on this and a companion piece in the Fortnum collection is akin to work signed by Antonio Patanazzi about 1580[2].

The arms indicate that the set was made for a bishop of the Piccolomini family of Siena; this family produced two Renaissance Popes and numerous bishops. It is uncertain who was the client in this case, but possible candidates include Francesco Maria Piccolomini, Bishop of Pienza and Montalcino from 1563 to 1599, and Jacopo Piccolomini, Bishop of Teramo from 1553 to 1581.

Maiolica. The foot is a nineteenth-century restoration by Cantagalli of Florence.
Diam: 23.8 cm.
Provenance: Given by C.D.E. Fortnum, 1888. Bought by Fortnum with another similar one (Fortnum 1897, C457) in London in 1856.
Bibliography:
Burlington Fine Arts Club 1887, no. 136 or 137;
Fortnum 1897, p. 80, no. C458.

[1] N. Dacos, *La découverte de la Domus Aurea et la formation des grotesques à la Renaissance* (Studies of the Warbug Institute 31, London and Leiden 1969).
[2] References in Wilson 1987, p. 154.

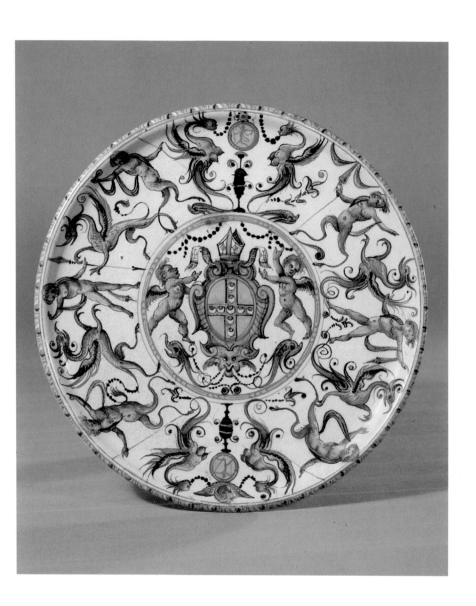

29 Two storage jars
Made by Giovan Paolo Savino in the workshop of
Maestro Diomede Durante, Rome 1600

The jars are decorated on the inscribed sides with
polychrome grotesques in the Urbino/Castel Durante
manner and on the other side with a leaf design in blue;
the latter is of a type associated by Piccolpasso with
Venice and Genoa, but was also in use in Castel Durante[1].
Rome occupies a surprisingly small place in the
history of Renaissance maiolica, and seems to have relied
mainly on imports from other parts of Italy for its
artistically ambitious pottery. However, there are docu-
mentary records of numerous immigrant potters, par-
ticularly from the Urbino region, having worked in
Rome, and a good many pieces attributed to other
centres may eventually prove to have been made in
Rome[2]. Marked pieces documenting Roman production
are uncommon[3].
The owner of the workshop where these jars were
made was Diomede Durante, a potter from Castel
Durante who is documented in Rome from 1590 to 1624[4].
The painter, Giovan Paolo Savino, was also from Castel
Durante, and a member of one of the town's most
distinguished potting families. By 1606 he was back in
Castel Durante, where he signed two plates, now at
Waddesdon Manor[5].

Maiolica, tin-glazed inside and out, inscribed on one *FATTO.IN
ROMA.DA.GIO.PAVLO SAVINO..MDC.*, and on the other *FATTO IN
BOTEGA DE.M.DIOMEDE DVRANTE IN ROMA*. It is not certain that
the lids originally belonged with the jars.
Height: 36 cm. each.
Some damage to both jars.
Provenance: Given by C.D.E. Fortnum, 1888. Bought by him in Rome
in 1870[6]. Previously owned by the Gaetani family.
Bibliography:
Fortnum 1873, pp. 461–462, 465, no. 1;
Burlington Fine Arts Club 1887, nos. 146 and 150;
Fortnum 1896, pp. 239–241; 'Marks and monograms', p. 86,
nos. 279–280;
Fortnum 1897, p. 82, nos. C465, 466;
G. Ballardini, 'Alcune maioliche romane del tardo stile cinquecentesco',
Capitolium 8 (1932), pp. 308–310;
Mallet 1978, p. 404, fig. 13.

[1] Piccolpasso 1980, II, p. 114.
[2] Documents on potters
from Urbino, Castel
Durante, and Faenza
working in Rome were
published by C. Grigioni in
Faenza between 1943 and
1954.
[3] Fortnum 1896, pp. 240–
241; Ballardini, *op. cit.*
[4] C. Grigioni, 'Figulini di
Castel Durante a Roma nel
Cinquecento', *Faenza* 32
(1946), p. 30. He may have
been a member of a major
Castel Durante potting
family, the Superchina,
several of whom worked
in Rome. Cf. Leonardi
1982, pp. 165–166.
[5] I am grateful to John
Mallet for information
on these plates, to be
discussed in detail in his
forthcoming catalogue of
the maiolica at Waddesdon.
Cf. Leonardi 1982, p. 166;
E. Liburdi, 'Vaserie
durantine del seicento',
Faenza 65 (1979),
pp. 82–83.
[6] This is the date given in
Fortnum 1873, p. 462; cf.
the letter of 1870 to Henry
Cole announcing their
purchase, J.V.G. Mallet,
'Storico e storicismo:
Fortnum, Cantagalli e
Castellani', *Faenza* 64
(1978), p. 46. Fortnum's
manuscript catalogue and
Fortnum 1896, p. 240, give
the date as 1863.

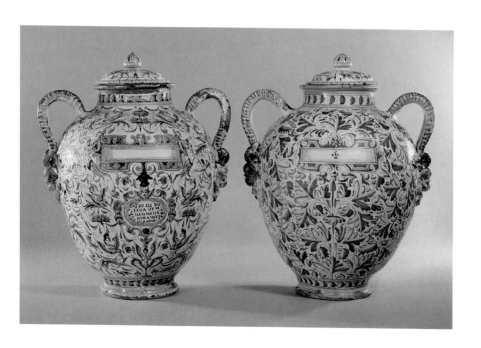

30 Plate, two young men with lutes
Probably Ferrara or Bologna, *c.* 1480–1510

Over much of northern Italy in the Renaissance the production of tin-glazed pottery was relatively rare. Particularly in the towns of the plain formed by the river Po and its tributaries, such as Padua, Mantua, Ferrara, and Bologna, the main form of pottery was incised slipware (sometimes known by the pseudo-Italian word 'sgraffiato'). Reddish-bodied earthenware was covered with a pale creamy 'slip' of liquid clay; a design was then scratched or scraped out of the slip to reveal the darker clay beneath, before being heightened with colour and given a transparent glaze. At its best, as in this example, incised slipware could almost rival maiolica in artistic aspiration.

Incised slipware is rarely marked or dated, and pieces similar in technique and design were made over a wide area. The most sophisticated and elegant pieces of this particular type, especially those redolent of a 'courtly love' atmosphere, are usually attributed to Ferrara, or sometimes Bologna, but there is little firm evidence: local attribution will remain hazardous until more scientific excavations of Renaissance sites have been carried out.

Incised slipware, the reverse slipped and glazed, but undecorated.
Diam: 40.3 cm.
Provenance: Given by C.D.E. Fortnum, 1888. Bought by Fortnum in London in 1856.
Bibliography:
Robinson 1863, no. 5153;
Burlington Fine Arts Club 1887, no. 184;
Fortnum 1896, pl. VII;
Fortnum 1897, p. 57, no. C401;
Rackham 1963, pl. 93;
Norman 1976, p. 54;
Mallet 1978, p. 400, fig. 2;
R. Magnani, *La ceramica graffita ferrarese tra medioevo e rinascimento* (Ferrara 1981–2), I, p. 113, tav XVIII.

[1] For the literature on incised slipware of the Po region, see Wilson 1987, p. 160; also W.B. Honey, 'Bologna pottery of the Renaissance period', *Burlington Magazine* 48 (1926), pp. 224–235.

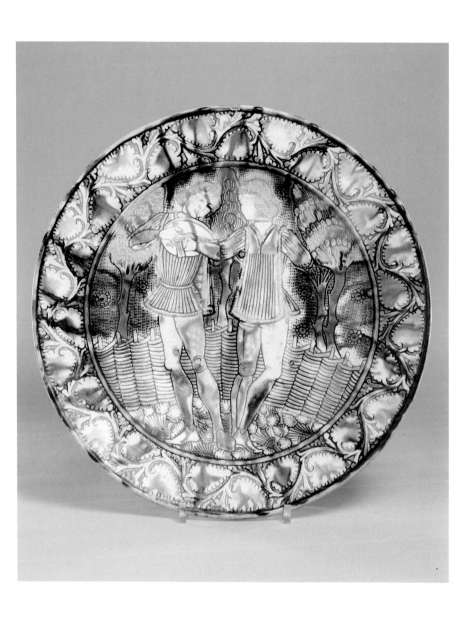

31 Shallow dish on low foot, marbled slipware
Probably Tuscany, second half of the sixteenth, or
first half of the seventeenth century

Marbled slipware of this type, in distant imitation of
agate, was a speciality of Tuscany from the middle of the
sixteenth century, though it was also made elsewhere. A
major production centre was Pisa, and Pisan slipware
was widely exported (pieces are frequently found on
archaeological sites in England)[1]; but there are no
marked pieces and no conclusive archaeological evidence
as to where the most highly-finished pieces, such as this
dish, were made[2].

Reddish-bodied earthenware, covered with a whitish slip, over
which have been swirled red, green, and brown slips to produce a
'marbled' effect. The reverse marbled in brown and cream.
Diam: 23.2 cm.
Provenance: Given by C.D.E. Fortnum, 1888.
Bibliography:
Fortnum 1897, p. 74, no. C440.

[1] J.G. Hurst, D.S. Neal, and
H.J.E. van Beuningen,
*Pottery produced and
traded in North-West
Europe 1350–1650,*
Rotterdam Papers VI,
Rotterdam 1986, pp. 33–37.
[2] A similar piece, probably
made in the same
workshop, is in the Cora
collection at the Museo
Internazionale delle
Ceramiche, Faenza (Bojani
et al., 1985, no. 723).

32 Ewer
Florence, after 1575 and probably before 1587

The ewer is one of about seventy known examples of 'Medici porcelain', which has been, since its rediscovery in the 1850s, one of the most highly valued types of European ceramics. Fortnum owned three pieces but in 1887 and 1889 presented two to the British Museum.[1]

Chinese porcelain was treasured in medieval Europe as a great rarity, but by 1500 was finding its way through Islamic trade routes into Italy, where various attempts were made to imitate its seemingly magical hardness and translucency. Experiments are recorded in Venice, Ferrara, and elsewhere, but the earliest European 'porcelain' of which any examples have been identified was made in Florence under the patronage of Francesco de' Medici, who became Grand-Duke of Tuscany in 1574 and was passionately interested in scientific, alchemical, and artistic experiments.

Medici porcelain is painted under a transparent glaze, in contrast to the on-glaze painting of maiolica. The main inspiration for the ornament was Chinese porcelain (of which the Medici had a large collection), with some secondary influence from Islamic blue-and-white, itself imitating Chinese models.[2] The shape of pieces like this is not oriental, but owes more to maiolica and to the goldsmiths, hardstone-workers and glass-makers who worked alongside the potters in Francesco's workshops. The firing temperatures required meant that the potters were working at the limits of Italian kiln technology, and many of the surviving pieces show firing defects; this piece, apart from a slight running of the blue, is virtually flawless. Porcelain production in Florence petered out after Francesco's death in 1587, and the project had no influence on later European porcelain.

Imitation ('soft paste') porcelain, painted in blue and blue-black. Marked with Brunelleschi's dome of Florence Cathedral and 'F'. Max. height: 18.5 cm.
Fortnum Bequest 1899. Bought by Fortnum in Naples in 1879; previously in the collections of the Montalvo family of Florence, Countess Matteucci di Montalvo, and Riblet of Florence.

Bibliography:
J.C. Davillier, *Les origines de la porcelaine en Europe* (Paris & London 1882), pp. 96–97, no. 10;
Fortnum 1896, p. 45, pl. I;
Fortnum 1897, pp. 61–62, no. C298;
S. de Ricci, 'La porcelaine des Medicis', *Faenza*, Commemorative Supplement 1908–1918 (1918), p. 27, no. 9;
G. Liverani, *Catalogo delle porcellane dei Medici* (Piccola Biblioteca del Museo delle Ceramiche in Faenza 2, Faenza 1936), p. 29, no. 21;
G. Cora and A. Fanfani, *La porcellana dei Medici* (Milan 1986), pp. 114–115.

[1] Wilson 1987, nos. 246, 247, with further bibliography. Cora and Fanfani, *op. cit.*, illustrate most surviving pieces of Medici porcelain.
[2] For the blue-and-white tradition, see J. Carswell, *Blue and White: Chinese Porcelain and Its Impact on the Western World*, exhib. cat., Smart Gallery, University of Chicago, 1985; and for the wider context, O. Impey, *Chinoiserie* (London, 1977).

33 Devotional bowl, the Madonna of Loreto
Probably made in the Marches (Loreto or nearby?), eighteenth century

The shrine of the Virgin at Loreto, near Ancona, was built around the *Santa Casa* (Holy House), which was supposed to be the house of the Virgin at the time of the Annunciation, and to have been miraculously carried from Nazareth to Loreto by Angels. During the fourteenth and fifteenth centuries, the shrine, which also contained a venerated statue of the Virgin and the *Santa Scodella* ('Holy Bowl') supposed to have been used by her, developed into one of the major pilgrimage centres of Europe. The miraculous powers of the shrine were held to be particularly efficacious against plague.

The bowl is painted with a scene of the Virgin and Child with the Santa Casa flying through clouds to Loreto; the iconography is similar to that of devotional broadsheets about the Madonna of Loreto[1]. Bowls of this sort were made for pilgrims, incorporating dust gathered in the *Santa Casa* and water taken from the *Santa Scodella;* no marked examples are known but they were probably made not far from Loreto[2].

Maiolica. Around the edge is the inscription *CON.POL.ET.AQVA.DI. S.CASA:* (with dust and water of the Holy House). On the underside is part of a red wax seal showing the Madonna of Loreto.
Diam: 11.3 cm.
Condition: The surface somewhat damaged in the kiln.
Provenance: Given by C.D.E. Fortnum, 1888. Bought by Fortnum in 1855.
Bibliography:
Fortnum 1873, p. 339;
Fortnum 1896, pp. 205, 239:
Fortnum 1897, p. 81, no. C464.

[1] Cf. F. Grimaldi, *Santa Maria Porta di Paradiso Liberatrice della Pestilenza* (Loreto 1987), pp. 34, 38–39.
[2] A bowl in the Victoria and Albert Museum (Rackham 1940, no. 1163), inscribed *EX PVLVERE PARIETVM, ET AQVA SACRÆ SCVTELLÆ ALMÆ DOMVS LAVRETANÆ 1728,* looks as if it may have been made at Castelli. Bowls of the present pattern are fairly common (e.g. examples in the British Museum, the Royal Museum of Scotland, and the Maidstone Museum), but I have never seen a dated one. Grimaldi *op. cit.* illustrates several examples from the collection at Loreto; bowls like the Ashmolean one are there attributed to Pesaro, but no reason is given.

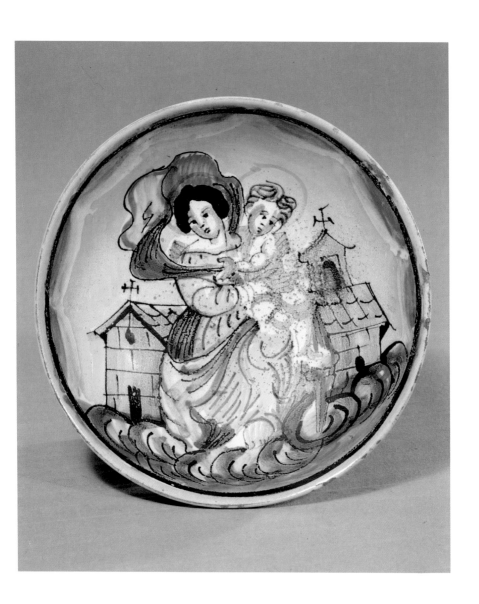

34 Plate, Neptune in his chariot
Attributed to Ferdinando Maria Campani,
probably in Siena, c. 1730–1740

Ferdinando Maria Campani of Siena (1702–1771), was the finest maiolica artist of the eighteenth century, as well as being an oil painter. His work is characterized by a taste for subjects from Raphael. The Ashmolean has one of the best groups of his work anywhere[1].

The scene represents Neptune, god of the sea, in a chariot pulled by sea-horses and accompanied by sea-nymphs. No immediate iconographical source has been found, but the same figures were used by Campani, in reverse, on a plate now in West Berlin[2]. The inspiration for the curious 'paddle-wheel' on the chariot is Raphael's 'Galatea' in the Villa Farnesina in Rome.

Maiolica, the reverse undecorated.
Diam: 32.5 cm.
Provenance: Given by C.D.E. Fortnum, 1888. Bought by Fortnum in London, together with three similar pieces.
Bibliography:
Fortnum 1897, p. 63. no. C414;

[1] Fortnum 1897, nos C413–417.
[2] Hausmann 1972, No. 312.

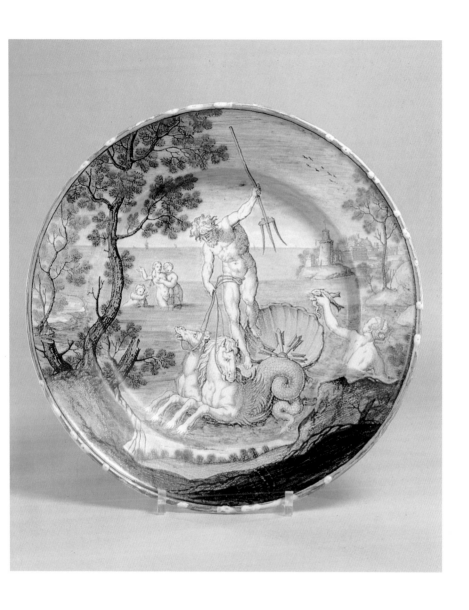

Glossary

Albarello: A cylindrical storage jar, usually slightly waisted and without handles; the shape is of Islamic origin but was much used in Renaissance Italian pharmacies.

Berettino: The Italian term for tin glazes stained blue or bluish-grey.

Bianco sopra bianco: Decoration in opaque white on an off-white glaze.

Grotesques: Decoration more or less in the fantastic style of ancient Roman wall-paintings. See no. 28.

Hispano-Moresque: Pottery, often lustred, made originally by Islamic craftsmen in southern Spain; in the fifteenth century made mainly in eastern Spain, particularly around Valencia.

Istoriato: 'Story-painted'; pottery painted with narrative scenes or figure subjects.

Italo-Moresque: Italian pottery made in the second half of the fifteenth century in imitation of Hispano-Moresque imports. See no. 2.

Lustre: The application to pottery, normally in a third firing, of iridescent metallic decoration; introduced into Italy shortly before 1500. The main Italian lustreware centres in the sixteenth century were Deruta and Gubbio. See p. 9.

Maiolica: In origin the word is a medieval Italian form of the name of the island of Majorca. Renaissance Italians used the term to describe Hispano-Moresque imports and other lustrewares, which were sometimes shipped through Majorca. In modern Italian (as in some parts of Italy already in the sixteenth century), its meaning has broadened to 'tin-glazed earthenware'. In English, it is used to refer to tin-glazed earthenware in the stylistic tradition of the Italian Renaissance. The spelling 'majolica' usually refers to Victorian and later wares of vaguely Renaissance inspiration.

Porcelain: A term originally used in medieval Europe to describe the high-fired, translucent wares made in China. The phrase 'soft-paste porcelain' is applied to Medici porcelain, and to the porcelains made at Sèvres, Chelsea, and elsewhere. The earliest European true or 'hard-paste' porcelain was made in Dresden from about 1708.

Slipware: Earthenware decorated with a clay 'slip' of runny dilute clay, usually of contrasting colour to the body clay. See nos. 30 and 31.

Tin glaze: A lead-based glaze made opaque white by the addition of tin oxide. In Renaissance Italy, tin had to be imported, from Cornwall and elsewhere, and was relatively expensive.

Bibliography of works cited in abbreviated form

Bibliographical note

There is a vast and rapidly-growing specialist literature on Italian Renaissance pottery: the reader is referred to Wilson 1987 for a wider picture of the subject and a fuller bibliography. Fortnum's own works, solidly based in the accumulation of notes on documentary pieces, formed the basis of modern scholarship and have kept much of their value. For an account of Italian maiolica's place in the tin-glazed pottery tradition, written by a distinguished practising potter, see A. Caiger-Smith. *Tin-Glaze pottery in Europe and the Islamic World* (London 1973). For the background, see R. Goldthwaite, 'The Economic and Social World of Italian Renaissance Maiolica,' *Renaissance Quarterly* 42 (1989), pp. 1–32.

Ballardini 1933–1938. G. Ballardini, *Corpus della maiolica italiana*, Rome.

Bojani *et al.* 1985. G.C. Bojani, C. Ravanelli Guidotti, and A. Fanfani, *Museo Internazionale delle Ceramiche in Faenza: La donazione Galeazzo Cora*, Milan.

Burlington Fine Arts Club 1887. *Burlington Fine Arts Club: Catalogue of Specimens of Hispano-Moresque and Majolica Pottery Exhibited in 1887*, London.

Fortnum 1873. C.D.E. Fortnum, *A Descriptive Catalogue of the Maiolica…in the South Kensington Museum*, London.

Fortnum 1896. C.D.E. Fortnum, *Maiolica*, Oxford.

Fortnum 1897. C.D.E. Fortnum, *A Descriptive Catalogue of the Maiolica…in the Ashmolean Museum, Oxford (Fortnum Collection).* Oxford.

Giacomotti 1974. J. Giacomotti, *Catalogue des majoliques des musées nationaux*, Paris.

Hausmann 1972. T. Hausmann, *Majolika. Spanische und italienische Keramik vom 14. bis zum 18. Jahrhundert.* Kataloge des Kunstgewerbemuseums Berlin VI. Berlin.

Join-Dieterle 1984. C. Join-Dieterle, *Musée du Petit Palais. Catalogue des Céramiques I: Hispano-Mauresques, majoliques italiennes, Iznik, des collections Dutuit, Ocampo et Pierre Marie.* Paris.

Kube 1976. A.N. Kube. *Italian Majolica XV–XVIII centuries: State Hermitage Collection.* Moscow.

Leonardi 1982. C. Leonardi, 'Il pavimento in maiolica della cappella dei conti Oliva', *Studi montefeltrani: Atti dei convegni II: Il convento di Montefiorentino.* San Leo: pp. 147–169.

Piccolpasso 1980. Cipriano Piccolpasso, *The Three Books of the Potter's Art*, ed. by R. Lightbown and A. Caiger-Smith. London.

Lessmann 1979. J. Lessmann, *Herzog Anton Ulrich-Museum Braunschweig. Italienische Majolika, Katalog der Sammlung.* Brunswick.

Mallet 1978. J.V.G. Mallet, 'C.D.E. Fortnum and Italian maiolica of the Renaissance', *Apollo* 108, pp. 396–404.

Norman 1976. A.V.B. Norman, *Wallace Collection, Catalogue of Ceramics I: Pottery, Maiolica, Faience, Stoneware.* London.

Rackham 1940. B. Rackham, *Victoria & Albert Museum, Catalogue of Italian Maiolica.* London. [Reprinted with corrections and additional bibliography by J.V.G. Mallet, London 1977].

Rackham 1963. B. Rackham, *Italian Maiolica*, 2nd ed., London.

Rasmussen 1984. J. Rasmussen, *Museum für Kunst und Gewerbe Hamburg, Italienische Majolika*, Hamburg.

Robinson 1863. J.C. Robinson, 'Majolica wares' in *Catalogue of the Special Exhibition of Works of Art…on loan at the South Kensington Museum, June 1862*, London.

Watson 1986. W. Watson, *Italian Renaissance Maiolica from the William A. Clark Collection.* Exhib. cat., Corcoran Gallery of Art, Washington, D.C., and Mount Holyoke College Art Museum, London.

Wilson 1987. T.H. Wilson, *Ceramic Art of the Italian Renaissance.* Exhib. cat., British Museum, London.

Principal towns and maiolica centres of Renaissance Italy

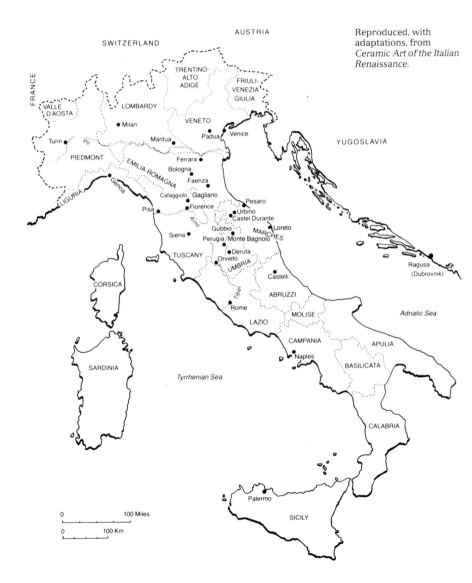

Reproduced, with adaptations, from *Ceramic Art of the Italian Renaissance.*

SWITZERLAND

AUSTRIA

FRANCE

TRENTINO-
ALTO
ADIGE

FRIULI-
VENEZIA
GIULIA

VALLE
D'AOSTA

LOMBARDY

VENETO

● Milan

Turin ●

Po

Mantua ●

Padua ●

Venice

YUGOSLAVIA

PIEDMONT

EMILIA-ROMAGNA

Ferrara ●

Bologna ●

Faenza ●

Genoa ●

Cafaggiolo ● Gagliano

Pesaro ●

LIGURIA

Pisa ●

Florence ●

Urbino
● Castel Durante

Arno

Gubbio ●

● Loreto

Siena ●

Perugia / Monte Bagnolo

MARCHES

TUSCANY

● Deruta

Orvieto ●

UMBRIA

● Castelli

Ragusa
(Dubrovnik)

Tiber

ABRUZZI

● Rome

MOLISE

LAZIO

Adriatic Sea

CORSICA

CAMPANIA

APULIA

● Naples

BASILICATA

SARDINIA

Tyrrhenian Sea

CALABRIA

Palermo ●

SICILY

0 100 Miles

0 100 Km

80